IMAGES
of America
AVILA BEACH

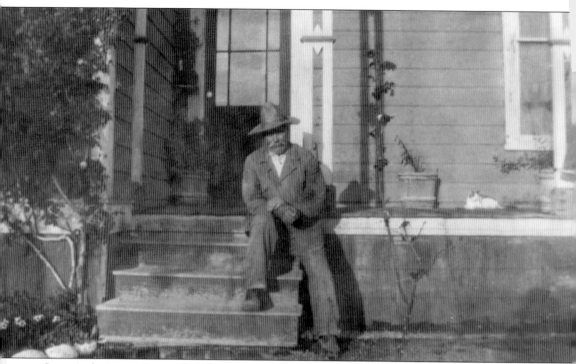

Juan Avila sits on the porch of his home on San Luis Street. The house can still be seen today with a slightly modified front. Juan was the son of Don Miguel and Inocenta, owners of the San Miguelito Rancho. The town of Avila was named for the family. (Courtesy of the History Center of San Luis Obispo County.)

ON THE COVER: This 1949 image of Front Street in Avila Beach was taken by Ray Foster for use on local postcards. (Courtesy of the History Center of San Luis Obispo County.)

Images of America
AVILA BEACH

Terry J. San Filippo, Jack San Filippo,
and Pete Kelley

Copyright © 2013 by Terry J. San Filippo, Jack San Filippo, and Pete Kelley
ISBN 978-1-4671-3073-8

Published by Arcadia Publishing
Charleston, South Carolina

Printed in the United States of America

Library of Congress Control Number: 2013938249

For all general information, please contact Arcadia Publishing:
Telephone 843-853-2070
Fax 843-853-0044
E-mail sales@arcadiapublishing.com
For customer service and orders:
Toll-Free 1-888-313-2665

Visit us on the Internet at www.arcadiapublishing.com

To Inocenta Avila, the first lady of Avila, Gerald M. Best, and our Avileños who shared their experiences, manuscripts and photographs, which allowed us to present this historical perspective of Avila Beach

Contents

Acknowledgments		6
Introduction		7
1.	The Founders	9
2.	The Wharves	17
3.	The Railway	29
4.	In the Bay	33
5.	The Oil	45
6.	The Fishing	57
7.	World War II Comes to Avila	65
8.	Our Heritage	87

Acknowledgments

We would like to say thank you to our old and new friends who shared their experiences, manuscripts, and photographs that allowed us to present this historical perspective of Avila Beach: the History Center of San Luis Obispo County; the South County Historical Society and the Point San Luis Lighthouse Keepers for granting unlimited access to their numerous resources; Bill Cattaneo for his advise and images; Pam Parsons and Vicki Hanson for their expertise; and our families and friends for their support during the creation of this book. A special thank you and appreciation to Madalene P. and Jack Farris for photographs and historical data. Photographs without credits have been generously approved for usage from the History Center of San Luis Obispo County.

INTRODUCTION

Buchon was chief of the northern Chumash's main village of Sepjato, located on the bluff overlooking the mouth of the San Luis Obispo Creek. It was one of the largest Indian settlements north of Point Conception.

The abundance of shellfish, especially abalone, on the Pacific Coast sustained these early native settlements. Acorns, berries, and other wild plants and fruit were in their diets, as were fish and local wild game.

The Chumash used asphaltum, a semisolid form of petroleum found naturally in the area, to caulk their planked canoes, called *tomols*. The Indians could fish far off shore, navigating up and down the coast, and even hunt whales. These were the earliest inhabitants of Avila Beach.

Mauro Soto Rosario Cooper, one of the last known speakers of the Obispeno Chumash language, lived in this area. Her work with noted linguist John Peabody Harrington in 1916 to preserve the language was invaluable.

One
THE FOUNDERS

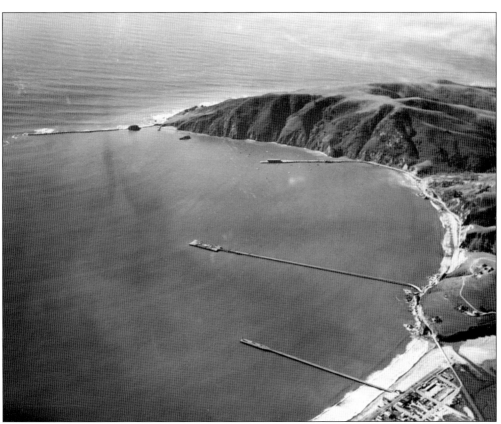

Miguel Antonio Avila was born in Santa Barbara in 1796. In 1824, he was promoted to corporal of the guard at Mission San Luis Obispo. Avila, a member of a prominent family, married the niece of Pio Pico (the last governor of Alta California), Maria Encarnacion Inocenta Pico, in 1826. He petitioned and was granted two land grants from Mexico that encompassed what are currently known as Point San Luis, San Luis Bay, and Avila Beach, over 22,136 beautiful Central California acres. The Avilas named their property Rancho San Miguelito.

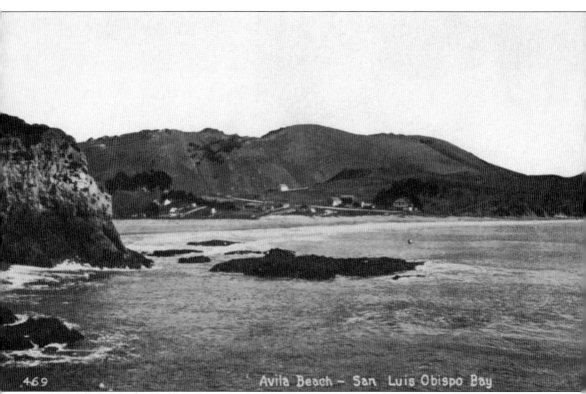

Inocenta's oral history *Cosas de California (Things of California)*, taken in 1878, told stories of a man who truly believed in doing the right thing, even in the face of adversity. She told a story of how she saved Miguel from being hung in El Pizmo (Pismo) when he was falsely accused of waylaying military funds arriving at Cave Landing to support Gen. José Manuel Micheltorena in the war with the Californios. She fed the soldiers, and they let Miguel return home. Miguel died in 1874 at his beloved Rancho Quemada, located near San Luis Creek. Soon thereafter, Inocenta and one of their sons, Juan, began laying out the beach community of Avila. Across the inlet, on the right, was the two-story Bay Hotel owned by Juan (today's Inn at Avila Beach). (Courtesy of the Michael J. Semas Collection.)

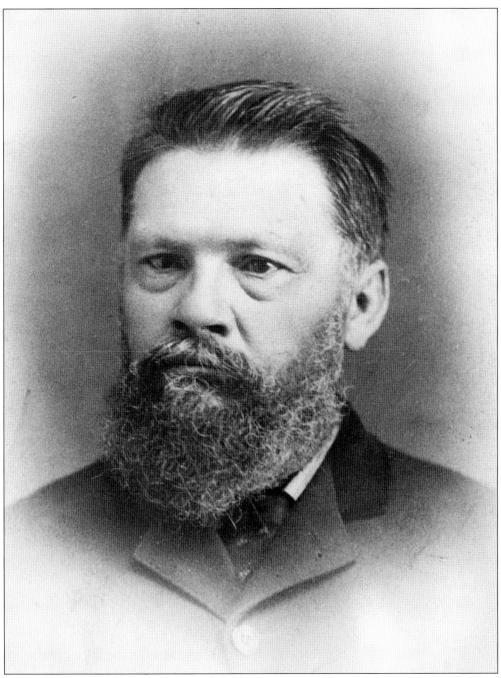
Moving to California in the 1860s with his wife, Margaret Harris, John Harford soon found business dealings in San Luis Obispo and the surrounding area. After purchasing land from the Avila family and buying into a lumber firm, Harford led other merchants in forming the People's Wharf Company in 1868. The intention was to build a wharf at Avila to foster local commerce and trade. By 1869, the wharf had been completed, stretching 1,800 feet into the bay. After a few initial troubles, Harford was able to hire on local wharfinger David Mallagh to run the People's Wharf, and business soon boomed.

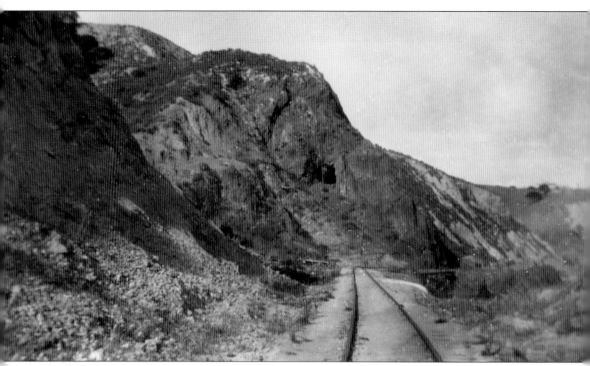

Harford always strove for improvement, and not content with the scope of operations at Avila Wharf, he soon laid down plans for yet another pier. Beginning in 1871, a year before he would sell his share of the People's Wharf operation, Harford set out to construct a new wharf at the west end of San Luis Bay. Initially reaching 540 feet into the harbor, the pier was notable for Harford's ingenuity in building a horse-drawn narrow-gauge railway connecting it to Avila. He hired a man named Ah Louis from San Luis Obispo to supply a Chinese work team, and the railway and pier were up and running by 1873. This image shows the railway with the tunnel.

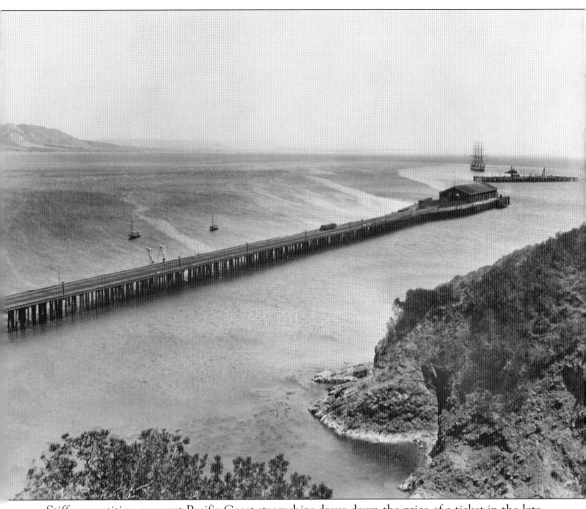

Stiff competition amongst Pacific Coast steamships drove down the price of a ticket in the late 1800s. For John Harford, this meant that business was fantastic, as affordable trips to San Francisco and elsewhere were now within reach of the general public. In 1878, the People's Wharf, which Harford had been instrumental in building and whose share he later sold, was destroyed in a great storm that battered Avila. Harford's new wharf stood, a testament to his skill and patience, and is still in use today.

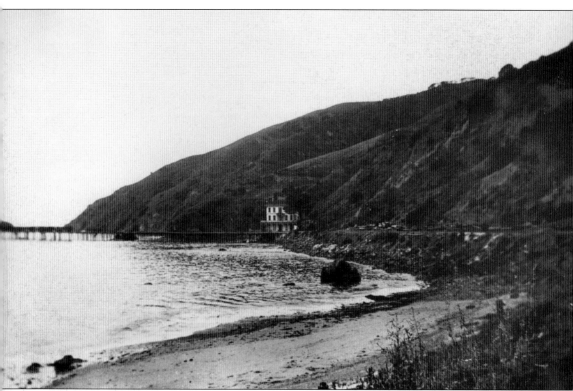

Luigi Marre traveled from Italy to San Francisco in 1854 at the age of 14. Physically well built and with keen mind, Marre had intently set out in search of California gold and adventure. Throughout the 1870s, he drove cattle from Mexico to Nevada and San Francisco. After spending some time in Southern California, Marre came to San Luis Obispo in 1879 and rented the Pecho Rancho. In the early 1880s, he bought the San Miguelito Ranch from John Harford, followed shortly by the acquisition of the Pecho Rancho plus another 2,500 acres of the Avila estate. In 1881, he married and had seven children. Marre and his two sons owned the largest cattle ranch in San Luis Obispo County and one of the largest in the state.

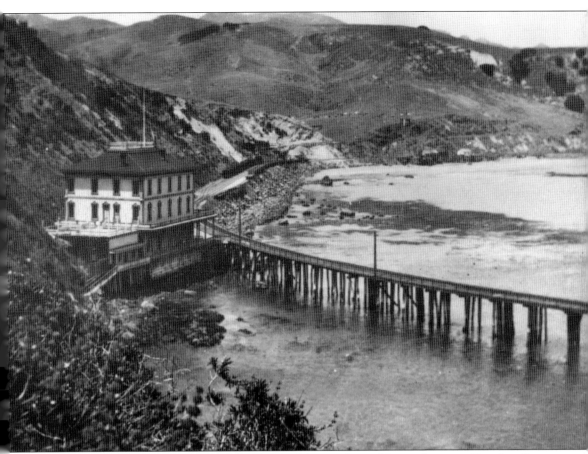

In the early 1880s, Marre purchased half of Avila's waterfront, 90 acres between Cave Landing and Avila, and 20 acres above Port Harford. The Ocean Hotel, situated at the foot of the Harford Pier, was purchased by Luigi in 1882 with his partner Antonio Gagliardo, an old friend from his San Francisco days. The hotel was known up and down the coast for its wonderful hospitality and fabulous bar. Luigi Marre died in 1903 in San Francisco and is buried in the family plot at the Catholic Cemetery in San Luis Obispo.

In the 1920s, Luigi's sons, Gaspar and Louis (Louie), began construction of a duplex on the top of the hill overlooking the bay and the town of Avila. The early California-style homes have large picture windows to view the entire bay. In the view to the west was their hotel, and to the east, the town of Avila.

Two

THE WHARVES

In 1855, two men by the names of Clement and Rommie built a pier at Cave Landing near Avila Beach. Preceding the People's Wharf by 14 years, their pier was one of the first constructed on the Central Coast. In 1864, the two men sold the pier to Capt. David P. Mallagh, a stock raiser and owner of a cattle ranch north of the Cuesta Grade. Mallagh had moved to Avila in the 1860s with his wife, Juana, and their five children.

As the family grew, so too did his business, and for over a decade, Mallagh's Landing was the only entry/exit point in Avila from the sea. In 1869, the People's Wharf was built in Avila Beach and became a direct competitor to Mallagh's Landing. In 1872, Mallagh signed a contract with People's Wharf's owner John Harford, agreeing to manage the new wharf. The landing that had served early Avila as well as San Luis Obispo since 1855 soon fell into disrepair but was still serviceable and well used during Prohibition.

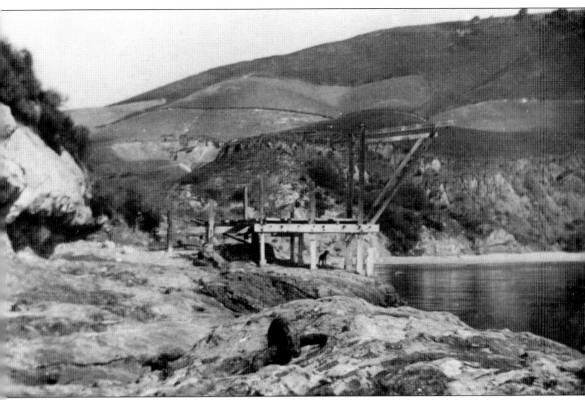

In 1932, local historian Constance Van Harreveld took this photograph of her dog Pal, who can be seen standing underneath the boatlift at Cave Landing. In the foreground lies an iron lynch pin, which would stabilize and moor small craft when loading and unloading at the landing.

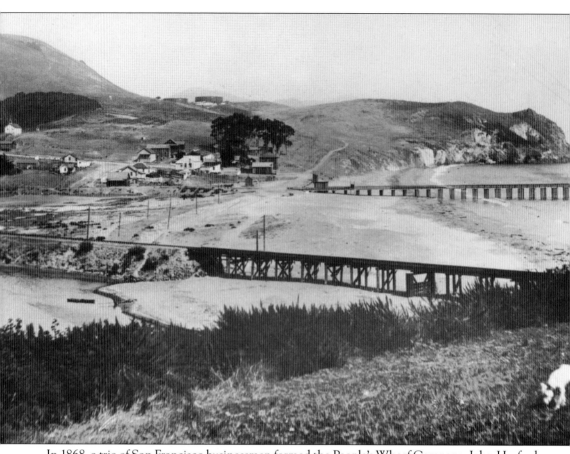

In 1868, a trio of San Francisco businessmen formed the People's Wharf Company. John Harford, already in the lumber business in Avila, was the principal entrepreneur. The People's Wharf in Avila was constructed at the foot of what is now San Luis Street but collapsed in a tidal wave in 1878.

Fanny Hodges and Olive Brown take a stroll on the Avila Pier. The rail tracks for the pushcart are on the right side of the two ladies.

The People's Wharf was destroyed by a tidal wave in 1878. The new pier, the Avila Municipal Pier (now called just the Avila Pier) was built in 1907.

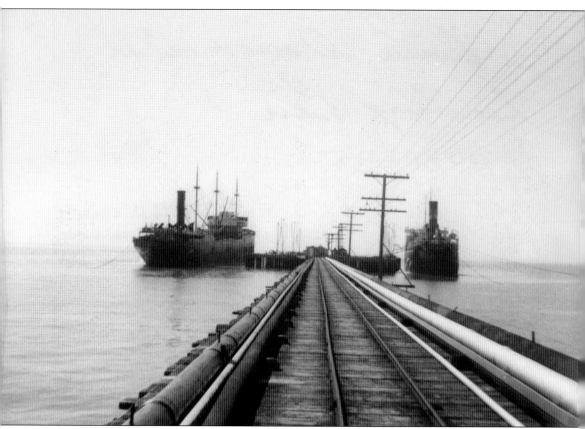

The Union Oil Pier was built in 1914 and was fitted with pipes. The pipes relayed various degrees of crude oil that would be pumped into the waiting ships. It was in use until 1983, when the wooden pier was destroyed in a fierce storm that struck Avila. In 1984, Unocal (the current name of Union Oil) built a new pier out of steel and concrete, which was donated to California Polytechnic State University's Center for Coastal Marine Studies in 2001.

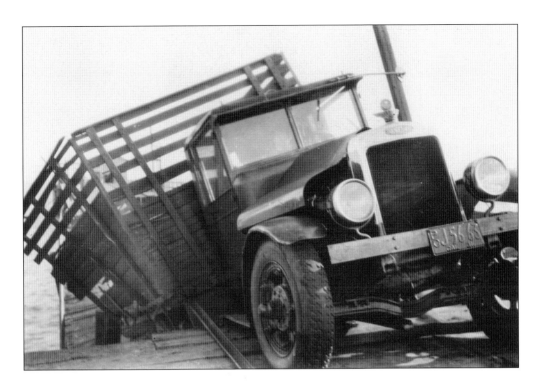

Two old-timers share a laugh on the back of a late-1920s Moreland truck that fell through the Avila Pier in the 1930s. Avila is visible in the background.

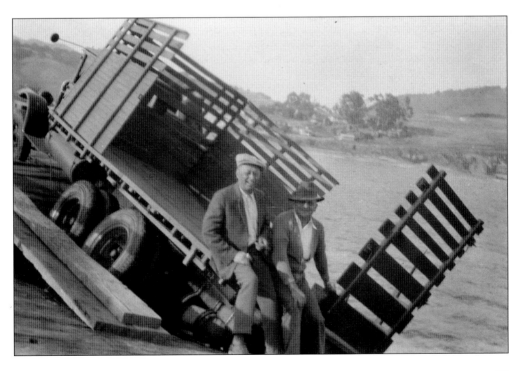

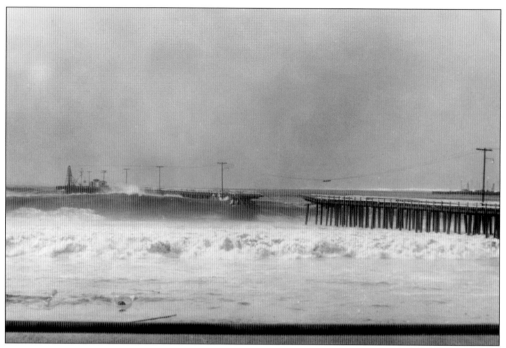

In 1960, a huge swell hit Avila and tore away pilings and planks, creating large gaps in the pier. Former Port San Luis Pier crew chief Henry Lepley estimated that the 1960 storm produced larger waves than the one that happened in 1983.

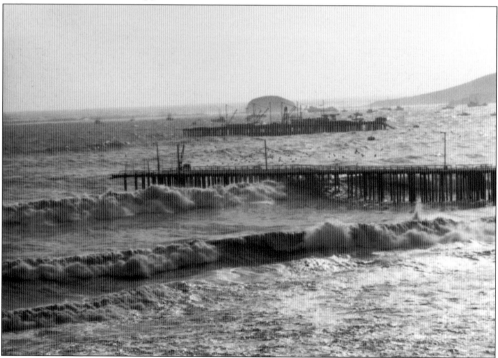

The March 1, 1983, El Niño storm wrecked havoc on both the Avila and Union Oil Piers. (Courtesy of Madalene P. and Jack Farris.)

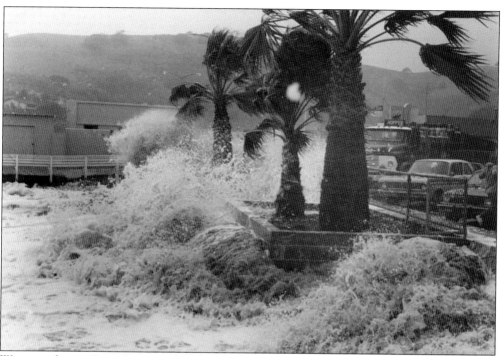
Waves wash over Front Street in this photograph, taken about a month before the March storm. (Courtesy of Pete Kelley.)

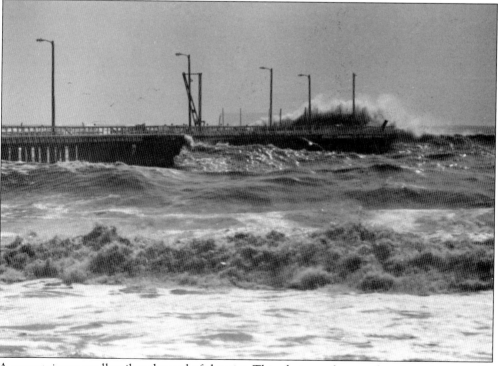
A mountainous swell strikes the end of the pier. This photograph was taken from the west side of Front Street. (Courtesy of Pete Kelley.)

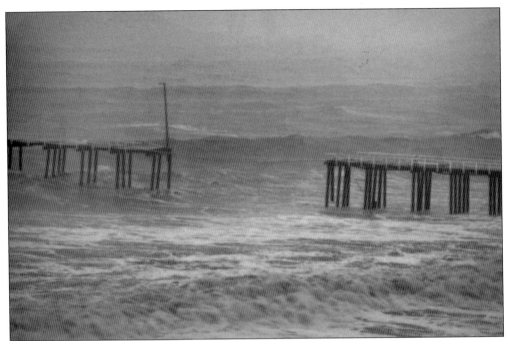

The Union Oil Pier collapsed in the storm of 1983. Locals who witnessed it said "it was pulled down like a stack of dominoes." (Courtesy of Madalene P. and Jack Farris.)

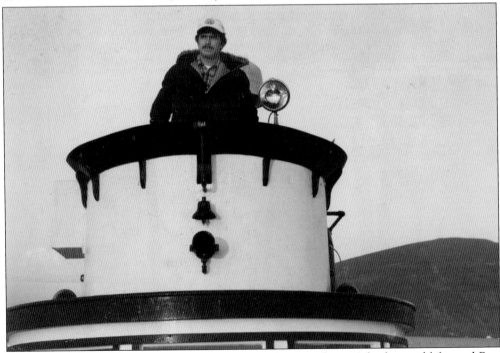

Skipper of the tug *Paul Revere* Keith Kelsey, shown here on the tug's bridge, and lifeguard Bret Percival were credited with the 1983 rescue of three Union Oil employees who were on the pier during the storm. "Dutch" Van Harreveld, Jack Spaulding, and Loren Woods fell into the ocean when the pier collapsed. (Courtesy of Keith Kelsey.)

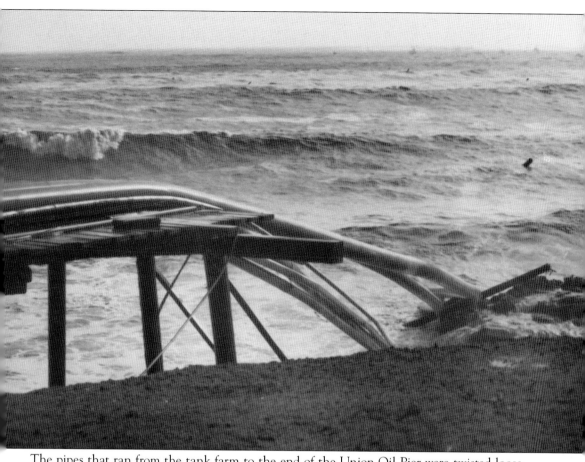

The pipes that ran from the tank farm to the end of the Union Oil Pier were twisted loose. (Courtesy of Madalene P. and Jack Farris.)

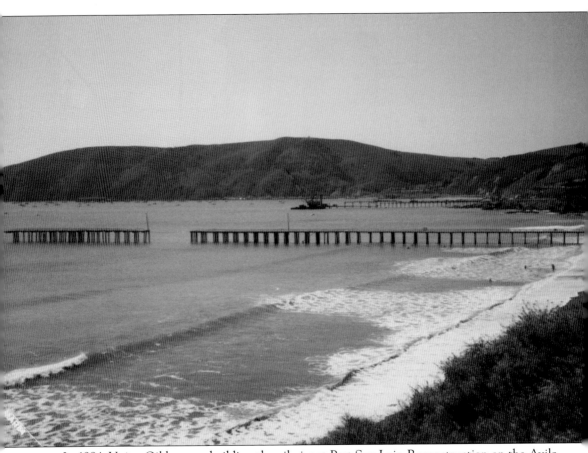
In 1984, Union Oil began rebuilding the oil pier at Port San Luis. Reconstruction on the Avila Pier would begin a year later. (Courtesy of Madalene P. and Jack Farris.)

Three
THE RAILWAY

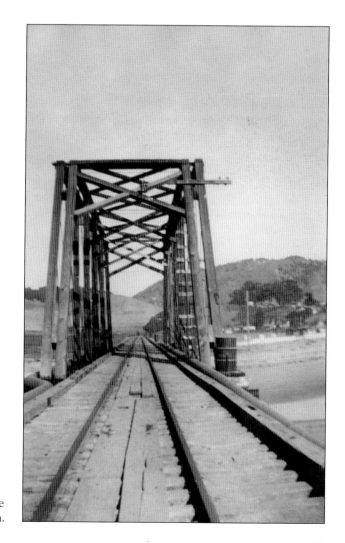

Businessman John Harford's vision for a steamship line to dock in the bay also needed a method of transporting cargo into San Luis Obispo and beyond. With the assistance of Chinese labor leader Ah Louis, the railway and pier were soon completed. This photograph shows the wooden railroad trestle between Port San Luis and Avila.

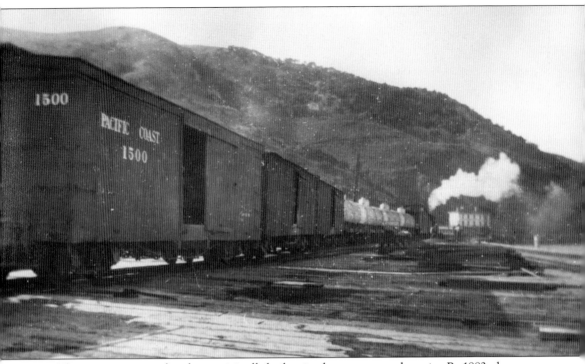
The narrow-gauge railroad was originally built using horsepower and gravity. By 1882, the narrow-gauge railway was renamed the Pacific Coast Railway and used steam engines as shown above.

This image, captured from what is now Bay Estates, views the railroad trestle between Port San Luis and Avila Beach and the San Luis Creek. (Courtesy of Madalene P. and Jack Farris.)

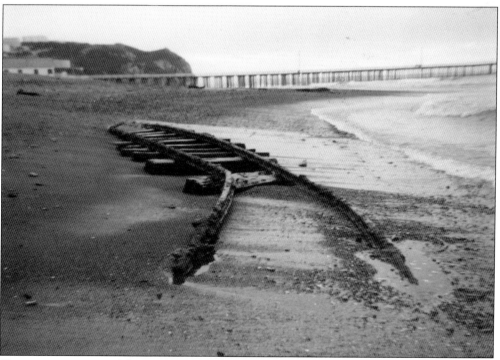

Shown are remnants of the 1890s spur track used to haul sand from Avila to Cuesta Grade. The track was uncovered in a 1960 storm.

Around 1874, financial backers and the state government authorized the formation of the San Luis Obispo & Santa Maria Valley Railroad. The railroad warehouse is on the left of the tracks near Port Harford.

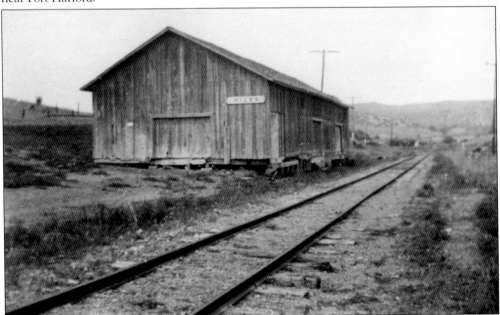

The Pacific Coast Railway headed toward San Luis but stopped at Ontario Road (near the Bob Jones Trailhead) due to a lack of funds. This "temporary" stop was called Castro's Place. A year later, in 1876, a brick store had been built, as had the Avila Palace Saloon. Next came a hotel, and a short time later, the name was officially changed to Miles Station, after the hotel owner. Miles Station was infamous for the common acts of banditry and violence that occurred there. The proposed towns of Harford and Ynocenta, near Miles Station, were never able to take root past their initial planning stages. As a railroad warehouse and depot, however, the station was prosperous. Grain farmers and others from the outlying area would store their produce at the warehouse. The produce would then travel up the railroad to the awaiting steamships.

Four
IN THE BAY

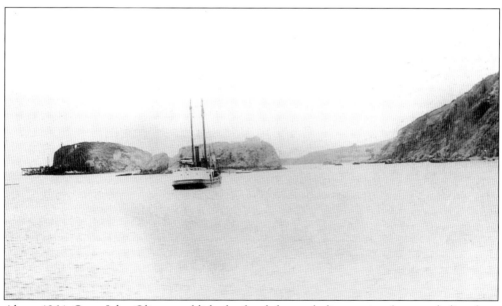

About 1864, Capt. John Oliver established a fixed shore whaling station (versus whaling from ships) inside Port Harford on what he called Whalers Island, pictured on the left, the larger of the two islands in the bay. The August 8, 1874, report states that 10 whales yielded 328 barrels of oil. A sperm whale kill brought a celebratory ration of grog to the whalers. (Courtesy of Madalene P. and Jack Farris.)

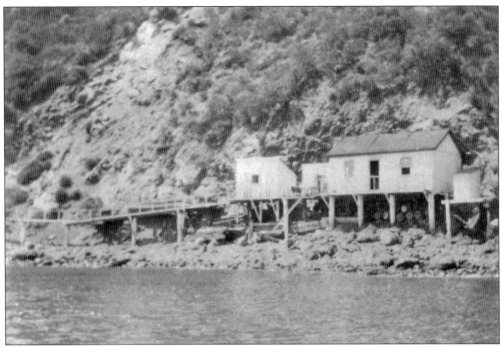

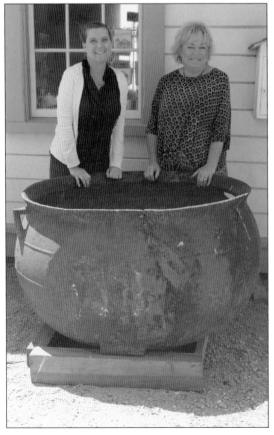

Antone Silva ran the beach whaling station on what is currently Lighthouse Beach. An 1890 landslide destroyed Oliver's station, and he left the bay. Silva then moved to Whalers Island and began a new station. In 1896, the lighthouse keeper, Capt. Jack Young, revoked Silva's permit to be on government property, ending shore whaling in the bay.

Each station was fitted with trypots—large, black, cast-iron pots—which can heat up to 200 pounds of whale blubber and render it into oil. The trypot in the photograph is from one of the abandoned whaling stations that were rescued from the beach by James Squire and his son Robert in 1890. Recently, their descendant Dan Carpenter donated the pot to the Port San Luis Harbor District. It is on display at the Point San Luis Lighthouse. Posing with the trypot are Point San Luis Lighthouse keeper and executive director Kristi Balzer (left) and volunteer and membership coordinator Deb Foughty. (Courtesy Point San Luis Lighthouse Keepers, T.J. San Filippo.)

This 1930s image shows Whalers Rock, the smaller Smith Island, and the Port San Luis breakwater. Smith Island is named for Mattie and Joe Smith, who lived there from 1884 until 1894. (Courtesy of Madalene P. and Jack Farris)

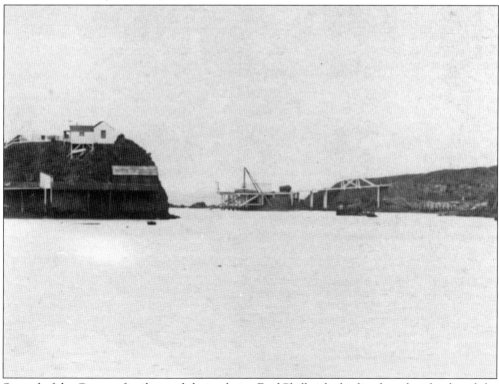

Several of the Gregory families and their relative Fred Philbrick also lived on the island, and the families built a pier connecting the island to the mainland.

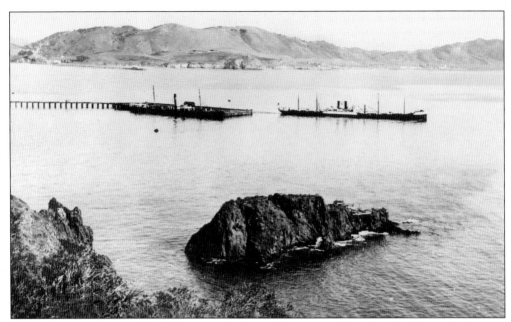

This 1910 image shows several houses on the lower left terrace of the island and a tanker leaving Port Harford Wharf. Local folklore claims that mothers tied ropes around their children's waists when they went out to play so they wouldn't fall into the ocean. (Courtesy of Madalene P. and Jack Farris.)

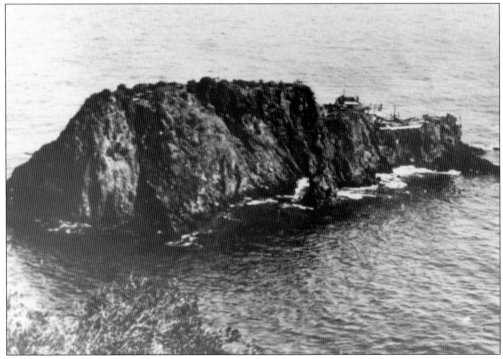

The terraces for the house foundations can still be seen today. The government phased out the use of the island for living, so the houses were either left to deteriorate or moved. One of the original homes still stands today at the top of San Luis Street in Avila Beach.

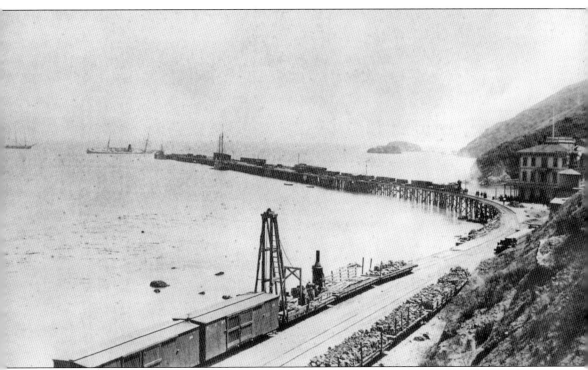

The 1888 sinking of the *Queen of the Pacific* (though it was later raised and restored) was a factor in the federal appropriations for the lighthouse to be funded. The ship, under the command of a Captain Alexander, began taking on water at sea and limped into the bay. Her passengers and crew were rescued, but she sank at the end of the pier. The captain's caution on rounding the rocky Point San Luis is credited with the lives saved. (Courtesy Point San Luis Lighthouse Keepers.)

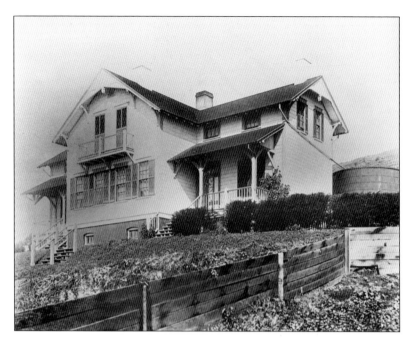

Once the Port Harford breakwater was built, a lighthouse was constructed at the rocky Point San Luis in 1890 to further aid with the safety of the ships coming into the bay.

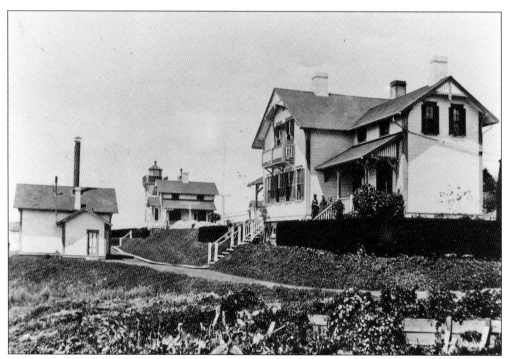

Structures at the light station include a pier, light tower, residences and privies for three families, fog signal building, coal storage building, oil storage building, barn, and freshwater cisterns. (Courtesy of the Point San Luis Lighthouse Keepers, Point San Luis Lighthouse Chronology.)

Appointed by Pres. Benjamin Harrison on May 22, 1890, Stephen D. Ballou was the first Point San Luis Lighthouse keeper. (Courtesy of Tim Storton.)

Constructed in the late-19th-century architectural style known as Prairie Gothic (common for lifesaving facilities on the East Coast at the time), the two-story light tower has been added to the main house. (Courtesy of the Point San Luis Lighthouse Keepers.)

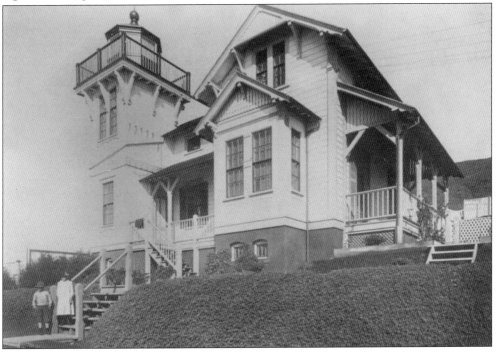

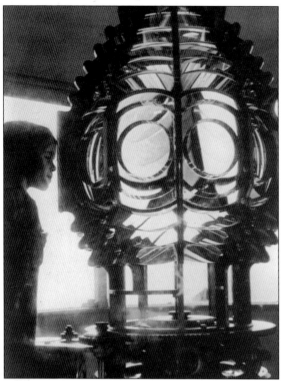

The handcrafted Fresnel lens was developed in France by French physicist Augustin-Jean Fresnel. Whale oil first powered the lamps, then kerosene, and finally electricity as technology improved. (Courtesy of the Point San Luis Lighthouse Keepers.)

Seen here in 1905, the lighthouse and its outbuildings were decommissioned in 1974 and acquired by the Port San Luis Harbor District (PSLHD). The nonprofit Point San Luis Lighthouse Keepers, under the PSLHD, restored the facility and now offer docent-led tours, hikes, and travel via tour vans and trolleys.

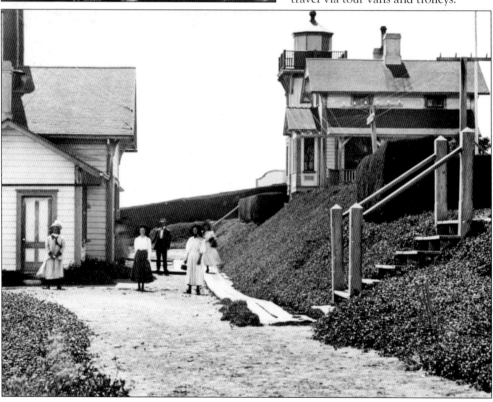

In front of the lighthouse, keeper Bob Moorfield (far left) gathers family and friends for a photograph. The children are Lucy and Robert Jr. (Courtesy of the Point San Luis Lighthouse Keepers.)

Keeper Moorfield and his son Robert Jr., also known as "Sonny," picnic at Lighthouse Beach, the east sand spit on the breakwater that protected the Coast Guard pier, visible in the background. (Courtesy of the Point San Luis Lighthouse Keepers.)

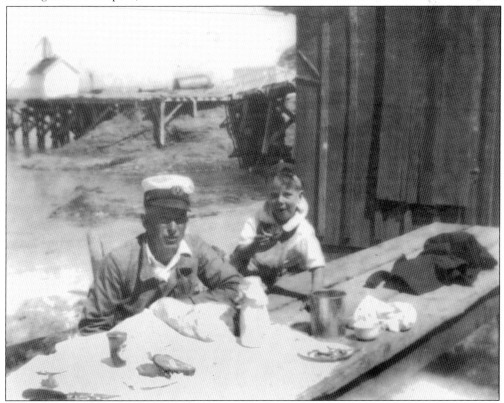

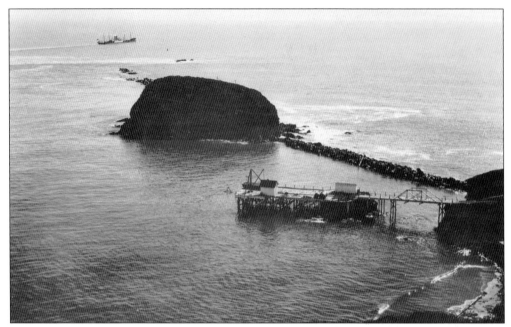

The well-protected Coast Guard pier was instrumental in landing provisions for the lighthouse keepers and their families. Over the years, the pier fell into disrepair, and now only occasional pilings can be seen near Lighthouse Beach during low tide. (Courtesy of the Michael J. Semas Collection.)

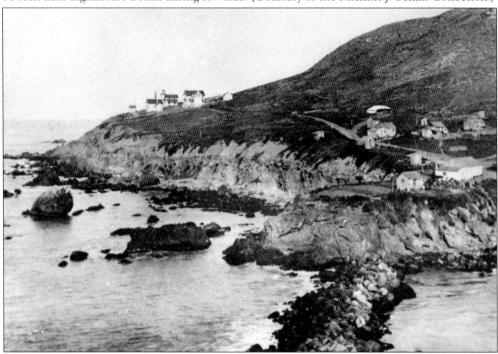

In 1992, the Port San Luis Harbor District received the 30-acre light station site from the federal government. In 1995, the Point San Luis Lighthouse Keepers, a nonprofit corporation to restore and maintain the light station and keep it open to the public, was formed. (Courtesy of the Point San Luis Lighthouse Keepers, Point San Luis Lighthouse Chronology.)

The Port San Luis Breakwater project was a long-term effort to protect ships in the port. The breakwater was initially constructed in 1890, but the inadequacies of this early jetty were soon made apparent, and it required a further shoring up using stronger materials. The main quarry was Morro Rock, although a quarry also existed on Bishop's Peak in San Luis Obispo. Rocks from both were used, but the Morro Rock boulders were the most affordable and were the majority used in the construction of the breakwater. The barge and tugboat's trip from Morro Bay to Avila was 15 nautical miles.

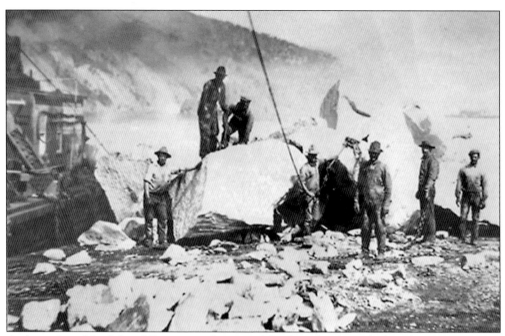

Avila residents like A.J. and Domingoes Simas and the Scuri family worked on the reconstruction of the breakwater. Here, they can be seen tightening the barge hoist around one of the massive multiton rocks before it is lifted and put into its place in the wall.

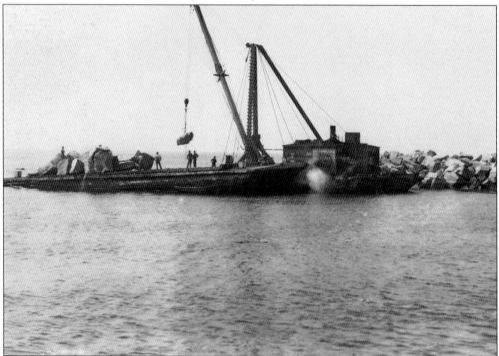

Utilizing tugboats and crane barges in order to collect the boulders that were blasted from Morro Rock, teams of Breakwater men worked hard to renovate the jetty at Port Harford. This photograph was taken in August 1913.

Five

THE OIL

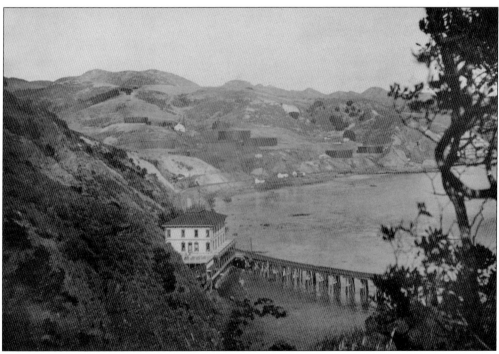

In 1890, three oil prospectors from Pennsylvania formed the Union Oil Company of California. They were drawn to the Central Coast by reports of oil being discovered in Santa Maria and Arroyo Grande. Union Oil utilized Port Harford Wharf to bring in shipments of raw materials to build oil storage on the hills around the bay. The company also used the Pacific Coast Railway for oil transportation before the use of pipes. Union Oil saw the advantages of the area, and between 1906 and when the oil refinery was dismantled in 1915, the hills behind Port Harford were lined with Union Oil tanks, pumping stations, and a refinery. Standard Oil Company also had storage tanks as well as a pumping station at Port San Luis. This photograph shows the tanks built around the bay.

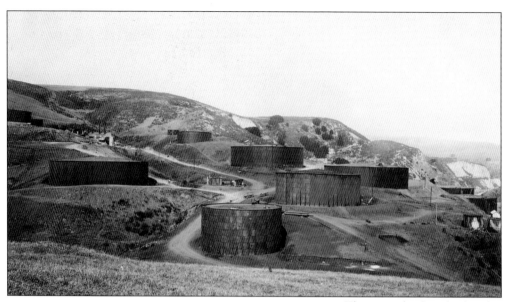

These are the Standard and Union Oil tanks and refinery at Port San Luis in 1906.

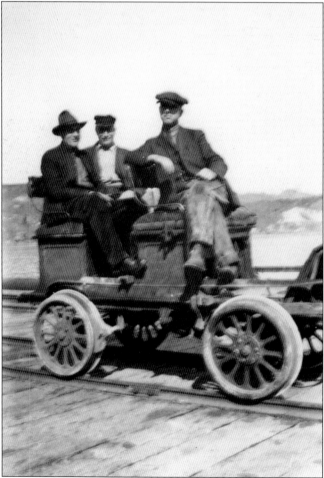

James S. Sullivan, an employee of the Union Oil Company, operates the converted horse wagon taxi that connected Avila Beach to Port San Luis around 1900. Later incarnations of this taxi service featured a converted Model T that was nicknamed around Avila the "Black Maria."

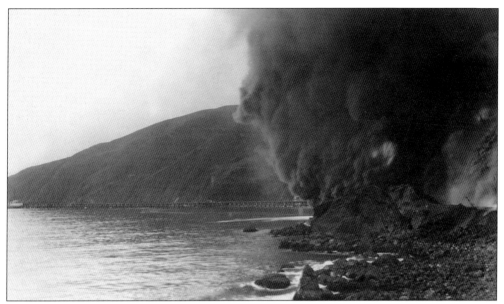

On January 27, 1908, a lightning strike upon the Union Oil tank farm at Port San Luis created a massive oil fire. It eventually spread to other tanks and to the Standard Oil pumping station, which was nearer to the ocean. The ensuing fire destroyed all Standard Oil property at Port Harford.

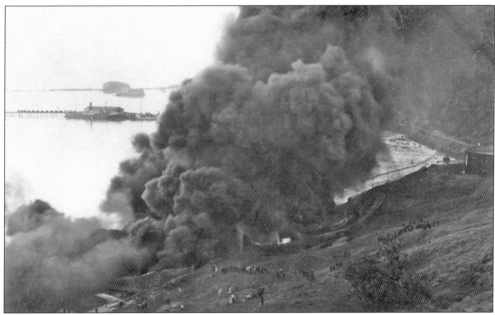

By January 28, 1908, townsfolk from Avila descended upon the area in order to assist in banking the oil fire with dirt. Spectators came as well to watch the massive tanks burn; the flames and smoke could be seen as far as San Luis Obispo.

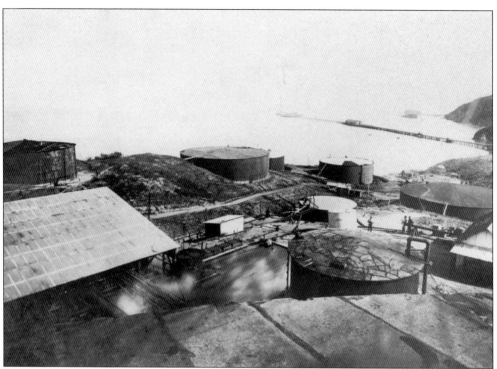

This 1910 photograph shows the expanded Union Oil compound on the hill behind Port Harford. By this time, the Harford Wharf had also expanded and now featured deep-water moorings.

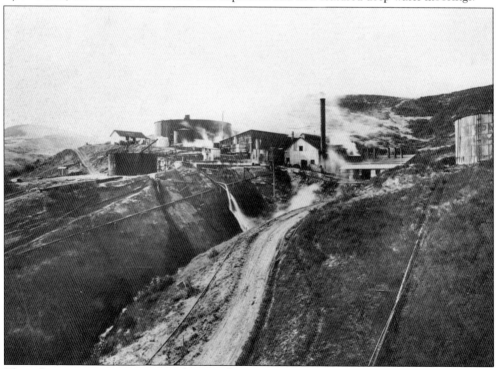

The refinery was in active use until 1920, when it was destroyed by fire.

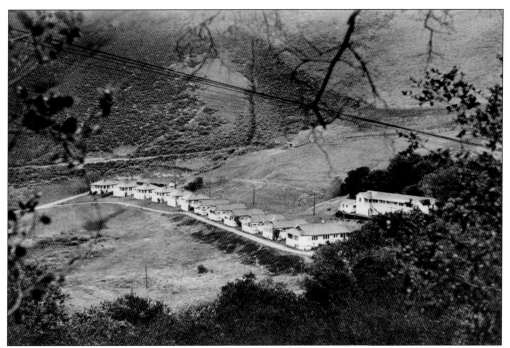

Located near Cave Landing Road and what is now Avila Beach Drive, the cottage row homes and adjoining barracks were home to Union Oil workers and their families from 1910 to around 1941, when the neighborhood was dismantled. This photograph was taken in the 1930s.

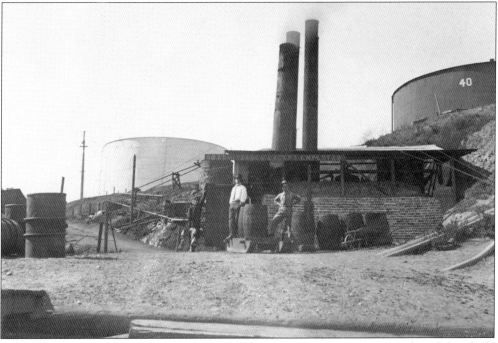

In 1941, the Union Oil Company decided to sell the cottages. Many renters purchased their little cottages and became homeowners. Several of these cottages were then moved into Avila and can still be seen today.

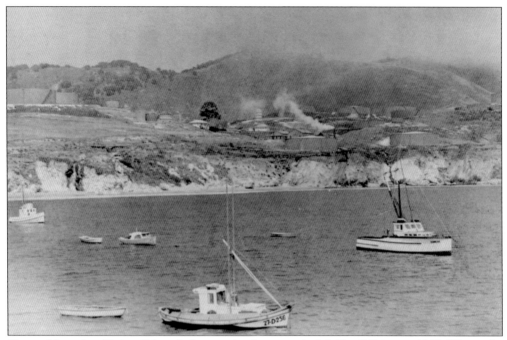

Pictured here is a Union Oil tank farm and refinery at Avila's Fossil Point in 1940. The tanks remained until the Union Oil cleanup of the town in the late 1990s–early 2000s. (Courtesy of Madalene P. and Jack Farris.)

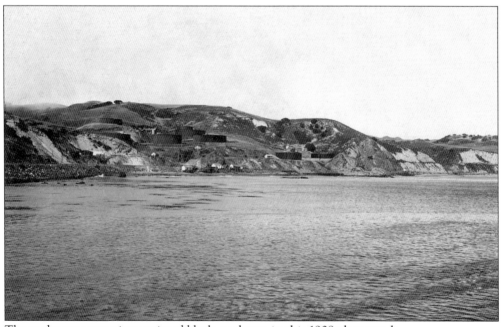

The tanks were sometimes painted black, as shown in this 1908 photograph.

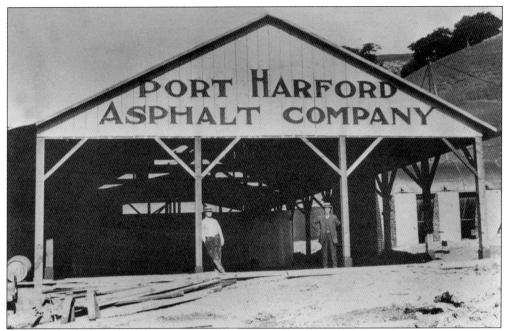

The Port Harford Asphalt Company was in production for only one year, 1911. Capitalizing upon the natural tar (called "pizmo" by the Chumash Indians) that was abundant in Avila, the asphalt company produced gas for gas lighting, as well as a large percentage of asphalt that would later pave the streets of reconstructed San Francisco.

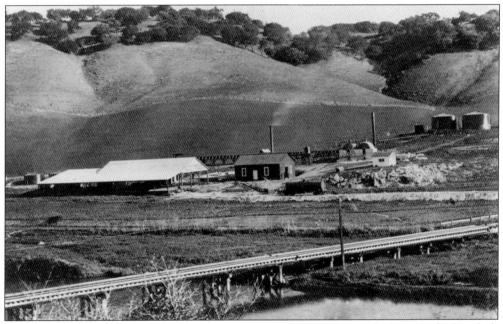

Nestled next to the hills that now border the Avila Beach Golf Course, the Port Harford Asphalt Company maintained the name "Port Harford," even after the departure of John Harford for San Francisco and the 1907 renaming of Port Harford to Port San Luis. This photograph was taken in 1911.

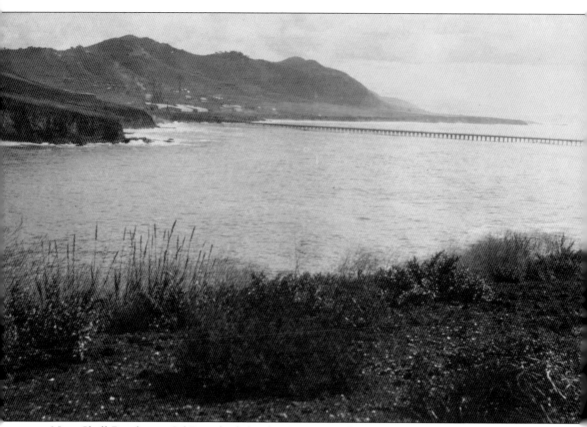

Near Shell Beach was Oil Port, built by the Graciosa Oil Company. It was expected to be the largest oil exporting spot in the world. Started at the beginning of 1905, the tank farm, port, and pier were completed at the end of 1907. Two weeks after the completion, in December 1907, a huge swell brought down the pier. The facility was never rebuilt and, for years, lay abandoned. The bluffs are now covered with homes.

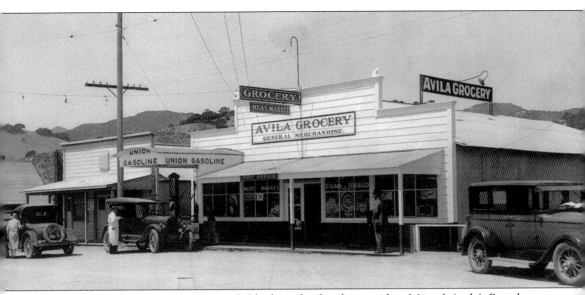

Vicente Canet, born in 1892, was a child when the family moved to Miguel Avila's Rancho Quemada to farm and raise cattle. In the early 1920s, he married Alice Martin. Their Avila Grocery store on Front Street became the social center of town, stocking everything from food to clothing to baseballs.

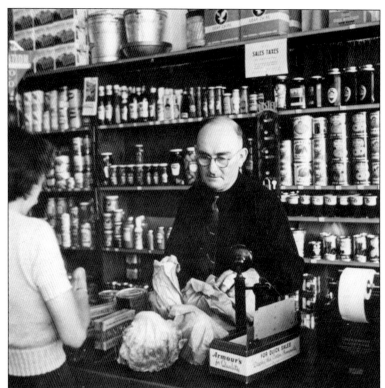

If a customer needed shoes, Vicente Canet would have them stand on a piece of paper and then draw around his or her foot. On Canet's next trip into San Luis Obispo, shoes in the correct size would be ordered to fit.

Throughout their lives, Vicente and Alice were Avila's historical stewards. Many of the photographs featured in this publication can be seen because the Canets shared their extensive archives with the local history centers and private citizens.

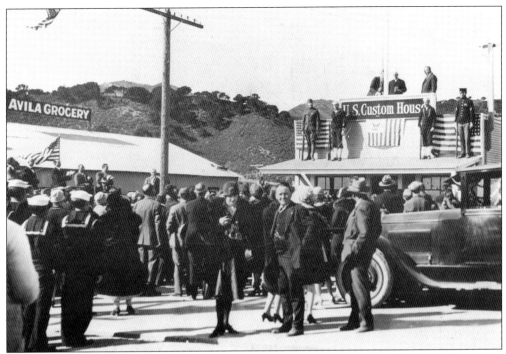

Due to the commerce from the steamships and the Pacific Coast Railway, a customhouse was needed in Avila. On March 19, 1927, the US Custom House was dedicated. Over 3,500 attended, with a count of over 200 cars. There was even a parade with a marching band. Located on Front Street, the Custom House later became a popular restaurant. (Courtesy of Madalene P. and Jack Farris.)

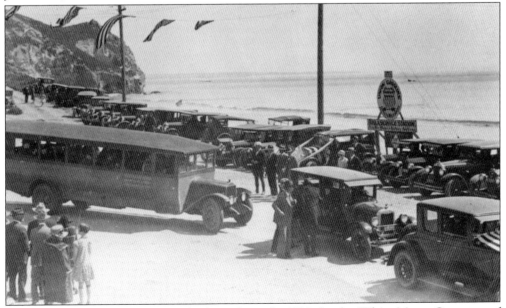

This model 50A touring bus was built in the early 1920s by the White Motor Company of Cleveland, Ohio. It was used to bring spectators to Avila for the Custom House's dedication ceremony. (Courtesy of Madalene P. and Jack Farris.)

Maria Madalene Pintor, seen here at eight months, was born on March 10, 1927, on San Miguel Street, just days before the Custom House dedication. The house can still be seen today across the street from the Avila Beach Civic Center and Garden. (Courtesy of Madalene P. and Jack Farris.)

On the left, Frank Dutra (left, in a striped shirt) his father, Frank Sr., and young Tony Dutra talk with Manuel Bettencourt, owner of the New Moon Inn. They stand in front of the Avila Grocery store on the day of the dedication.

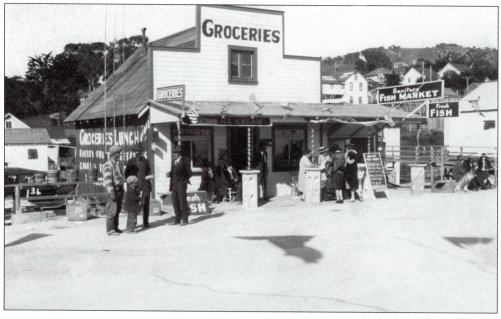

Six

THE FISHING

In the 1880s, the fishing vessels were brought up on the sand flats to be repaired. Don Miguel Avila's adobe home can be seen in the background. Other structures are the Marres' barn and slaughterhouse.

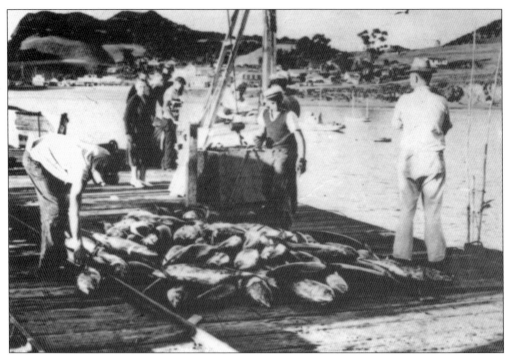

In 1939, an increase in fish numbers was attributed to the atmospheric weather condition called El Niño, which began a multiyear run. The J. Farris Fish Company packed the catch on ice and sold it from Fresno to San Pedro. (Courtesy of Madalene P. and Jack Farris.)

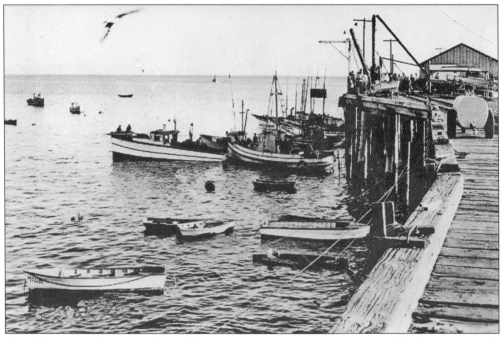

Each fish weighed between 25 and 50 pounds, with some weighing in at 70. Average records from the company gave average daily catches of albacore at 25 tons. (Courtesy of Madalene P. and Jack Farris.)

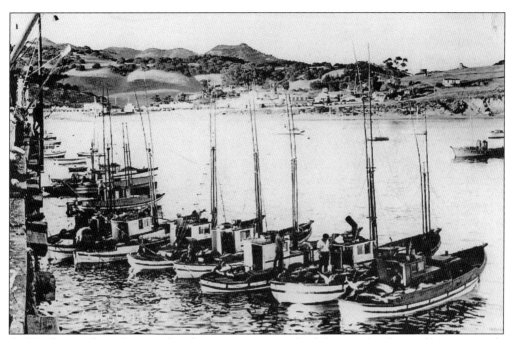

Avila's albacore fleet—boats tied to the pier, waiting to unload their catch—featured Monterey-style double-ender boats with pointed bow and stern and specialized poles. (Courtesy of Madalene P. and Jack Farris.)

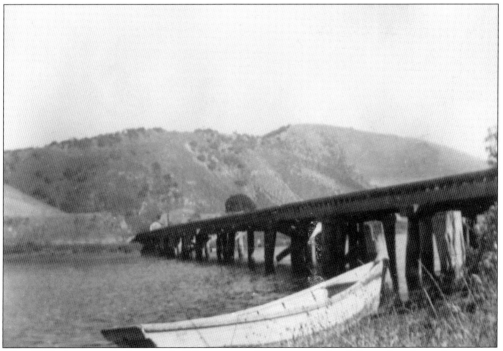

This 1937 photograph shows a skiff lying near the western side of the railroad trestle crossing San Luis Creek near San Miguel Street. Fishermen would sail their boats up the creek, pull their boats onto the shore, and use the area as a dry dock to make repairs.

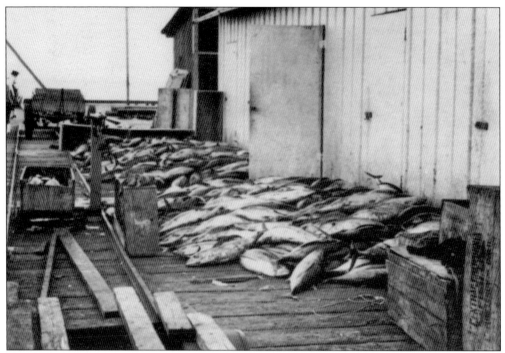

The fish were loaded into carts on a narrow track, pushed to J. Farris Fish Company in Avila, and then trucked to the markets from San Pedro to Fresno. (Courtesy Madalene P. and Jack Farris.)

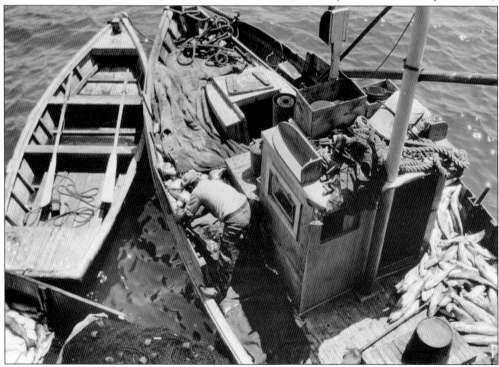

Sea bass, a delicious local fish, is being unloaded on the Avila Pier. There are so many fish that this fisherman hardly has room for them on the deck. (Courtesy of Chris and Lori Benton.)

Of Portuguese descent, Tony and Joe Sylvester owned and operated Sylvester Brothers Abalone Processing Plant. In the 1930s and 1940s, the plant was located at the end of Port Pier. In the 1950s, they moved it to Front Street. Joe ran the shop and processing plant, while Tony did the diving. While owning the business, they sold abalones from Ventura to Santa Cruz. This image shows Tony in his dive suit with another brother, Manuel Jr., who tended his dive lines. They are surrounded by a good day's catch of abalones. (Courtesy of Keith Kelsey and the Sylvester family.)

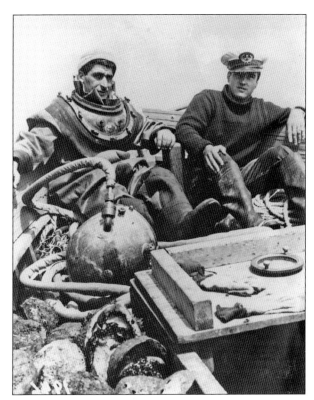

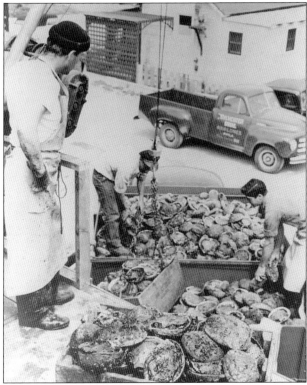

Joe Conway, Tony Sylvester (far left), and George Silva unload abalones into Sylvester's abalone processing plant. Once the business closed, they sold the building to Tom and Barbara Dessios, who opened the Barbara by the Sea bar. (Courtesy of Dorothy Sylvester.)

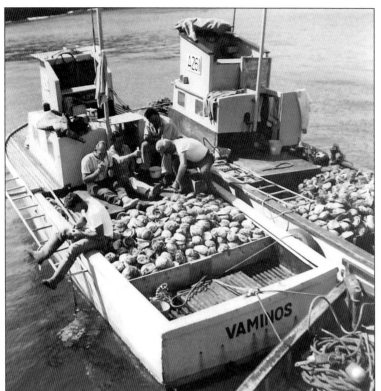

Here is a photograph of fishermen hauling in a full load of abalone during those days when the gastropod was king. The Benton brothers, Ted and Bob, had two boats in Avila, the *Vaminos* and the *Muy Pronto*. (Courtesy of Chris and Lori Benton.)

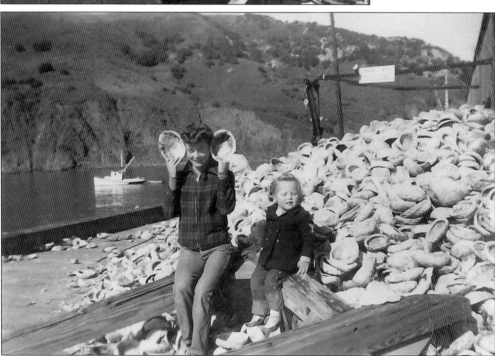

Pictured by this huge pile of abalone on the Port Harford Wharf, now renamed Port Pier, Betty Benton clowns around with her daughter. (Courtesy of Chris and Lori Benton.)

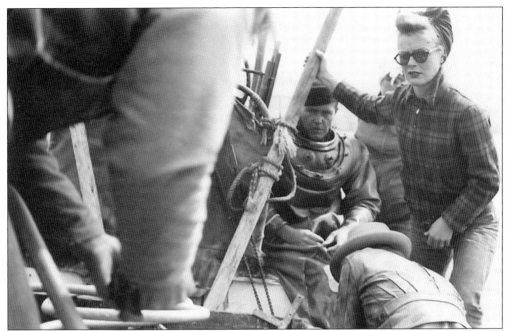

Betty Benton tends on the Bentons' abalone boat. A tender made sure the air hose didn't get tangled or hung up in the kelp or on a rock. (Courtesy of Chris and Lori Benton.)

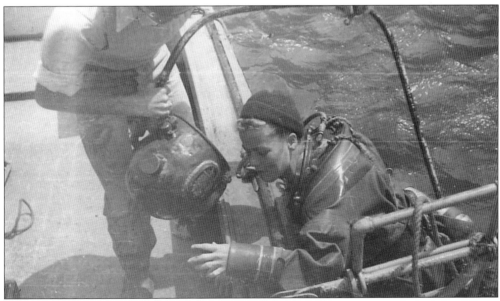

Betty Benton also donned a diving suit. Fellow diver Johnny Montgomery took Avila local Betty Gillam Woody diving as a teenager. Woody said, "Walking on the ocean floor was the highlight of my youth." (Courtesy of Chris and Lori Benton.)

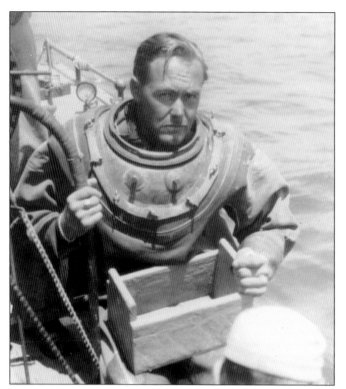

Capt. Bob Benton wears his diving suit. His diving bell helmet has been removed. Captain Benton reported that taking up to 200 dozen abalones at a time was the record. (Courtesy of Chris and Lori Benton.)

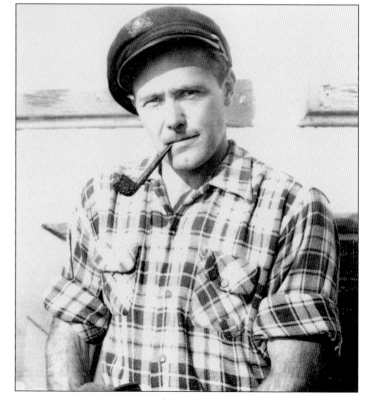

Here is Ted Benton smoking his pipe and looking very nautical with his skipper's cap. He claimed that over 16 million pounds of red abalone was harvested during the 1940s. (Courtesy of Chris and Lori Benton.)

Seven
WORLD WAR II COMES TO AVILA

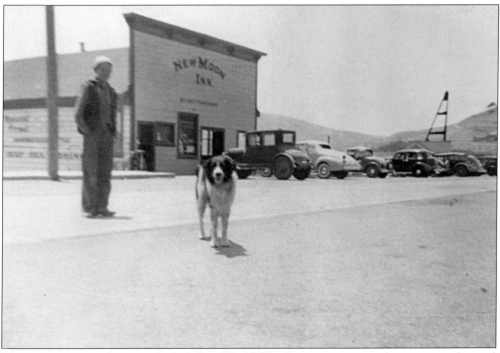

There were seven saloons in Avila before World War II, catering to merchant seamen from oil tankers docking at the pier. The most famous, New Moon Inn, was located on Front Street with its back door facing the beach. (Courtesy of Madalene P. and Jack Farris.)

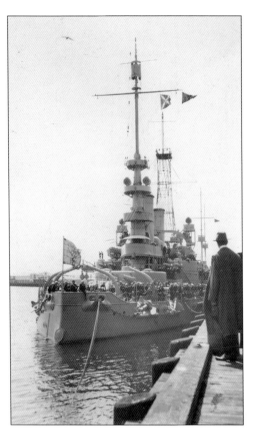

Norwegian Lines tankers displayed yellow and brown stripes, and Shell and Texaco ships featured brightly painted smokestack emblems. Gasoline and crude oil were piped along the Union Oil Pier from the storage tanks rimming the southern edge of town.

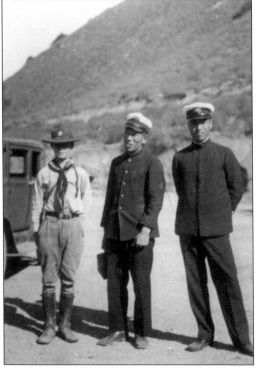

While in port, crewmembers from the various oil tankers visited Avila and took walks around town, hiking up into the surrounding hills. This image shows an Avila Scout posing with two Japanese seamen. (Courtesy of Perris Bernardo and Lester and Lydia Johnson.)

Before December 1941, Avila saw firsthand the United States' buildup of war preparedness as soldiers on leave from nearby camps San Luis, Roberts, Fort Hunter Liggett, and Cook (now Vandenberg) visited the seaside community. Here, Marion Richards shares a "fish-that-got-away" story on the Avila Pier. (Courtesy of Jan Felser.)

The Union Oil pipelines and surplus fuel in the large oil tanks made the small, quiet bay community a vital location to defend. (Courtesy of the Michael J. Semas Collection.)

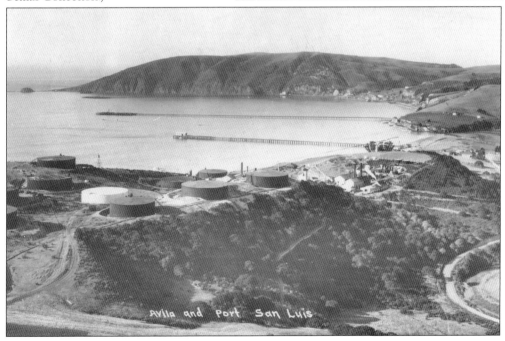

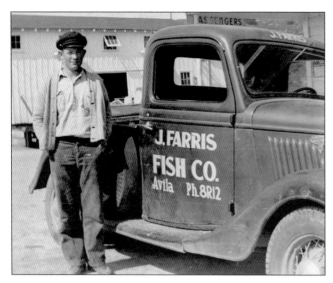

On December 7, 1941, 17-year-old Jack Farris took out a party of Camp San Luis soldiers on the family's deep-sea fishing boat, the *Lucky Boy*. Docking back at the Avila Pier that afternoon, guests and crew were informed of the Japanese attack on Pearl Harbor. That evening, Jack, Earl, and Eulis "Big Jack" were asked by the Point San Luis Lighthouse keeper, Robert Moorfield, to take their boat out in the bay and place rope-tied gunnysacks over the buoys to silence the bells from Avila to Estero Bay. (Courtesy of Madalene P. and Jack Farris.)

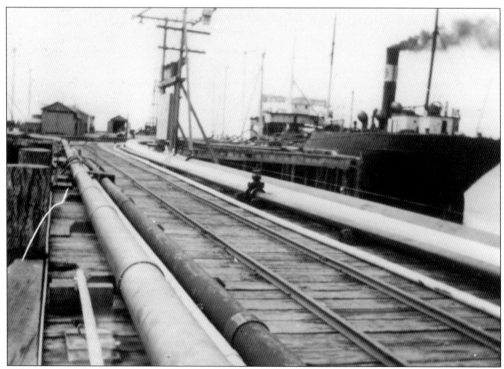

After Pearl Harbor, Union Oil Pier crews in Avila were assigned to watch for saboteurs. The tankers that had come into port before December 7 were kept at anchor and the loading terminal shut down. On December 23, the *Montebello*, carrying 73,571 barrels of oil, was the first Union Oil tanker commanded to leave the harbor; however, enemy submarines had been sighted along the coast, and the captain refused the order, resigning. The first mate, Olaf Eckstrom, was promoted to captain and took the *Montebello* out on her last voyage. (Courtesy of Perris Bernardo and Lester and Lydia Johnson.)

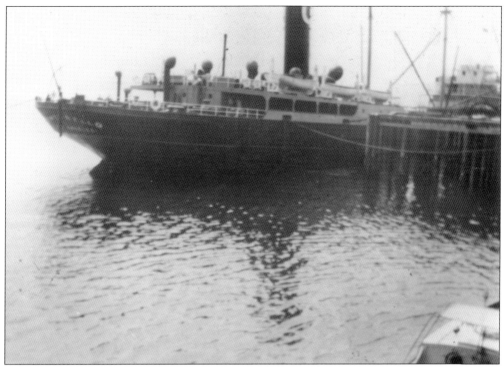

On December 23, 1941, the 8,000-ton *Montebello* was struck by a torpedo from the Japanese submarine *I-21* under Comdr. Matsumura Kenji four miles off Estero Point near the town of Cambria. The torpedo hit into a dry cargo hold. (Courtesy of Perris Bernardo and Lester and Lydia Johnson.)

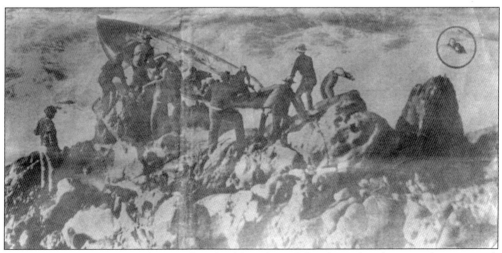

Eckstrom ordered the ship to be abandoned. Although strafed with gunfire, the crew of 36 was saved, some by the tugboat *Alma*. This newspaper image shows the fortitude of Cambria citizens rescuing the crew on rocky outcroppings in heavy seas. (Courtesy of the San Luis Obispo *Tribune*.)

Machine-gun fortifications were quickly built in the hills overlooking the town and facing the bay. The battlements were manned by soldiers, but the town's kids—those who ventured close enough to know—said the "guns" were lumber cut-outs made to resemble the real thing. (Courtesy of Mary and Jim Bachino.)

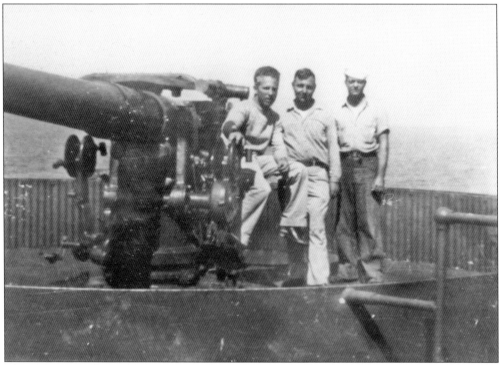

The Coast Guard turned the Custom House into its command center. Meanwhile, the Navy, which controlled the piers and the bay, used the yacht club for a base. Here, Navy personnel pose with a cannon on their ship, docked in Avila during the war. (Courtesy of Perris Bernardo and Lester and Lydia Johnson.)

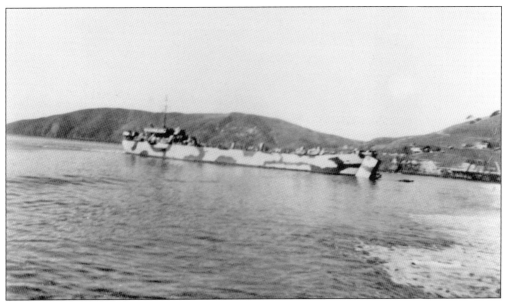

The Navy and Army practiced maneuvers in Port San Luis Bay. Townsfolk would cheer when the solders landed on the beaches as a show of support. (Courtesy of Perris Bernardo and Lester and Lydia Johnson.)

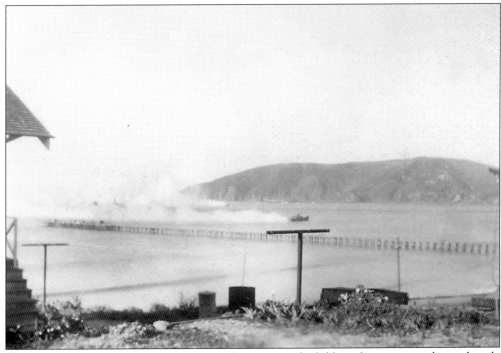

The military was also trained to create smoke screens, which blotted out a sunny day and made it seem as if fog were rolling in. This image shows a training vessel blowing smoke into the bay. (Courtesy of Beverly McAnallan Farris.)

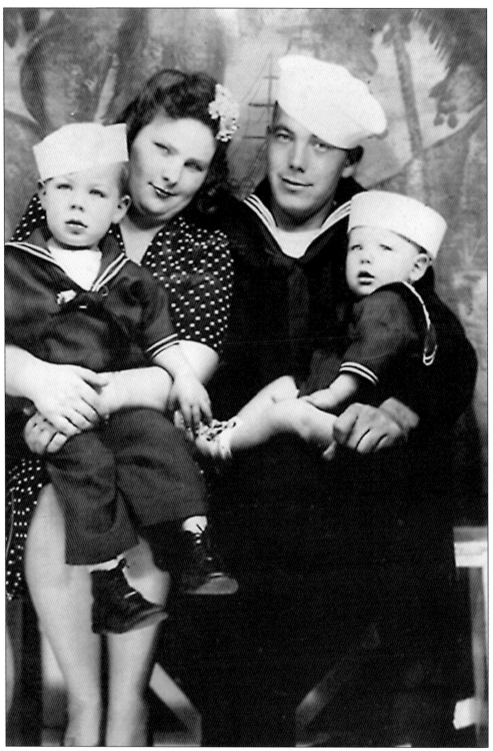
While on shore leave, Richard St. John from San Luis Street poses with his wife, Kay, and two tiny sailors: Jimmy (left) and Johnny. (Courtesy of Nadine Lewis.)

Earl B. Farris, one of 10 children, ran party boats with his family off the Avila and Pismo wharves starting in 1933. Earl skippered the largest, the *Lucky One*; it was only $2 to fish, and the pole was included. (Courtesy of Madalene P. and Jack Farris.)

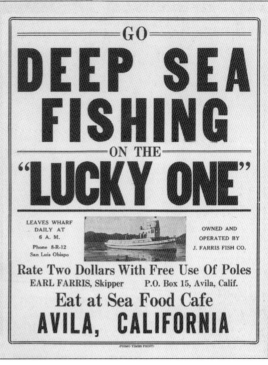

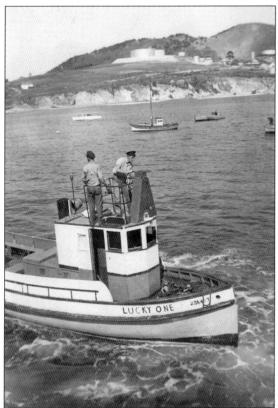

Before Pearl Harbor, Earl and his brother "Big Jack" towed targets for Navy shooting practice. He said usually "the crews were inexperienced, but one time he towed for a crew that could shoot the eye off a gnat. They almost cut my boat in half! So, I cut the tow rope!" (Courtesy of Madalene P. and Jack Farris.)

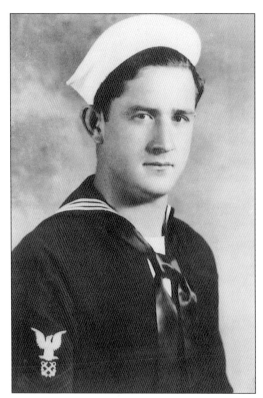

An experienced sea captain, Earl enlisted in the Navy in 1942 at age 27. He was assigned to the 7th Fleet Headquarters in Manila Bay, Philippines, where he ran boats and served as a supply officer. Below is Earl's brother Eulis "Big Jack," who served in the European theater. (Both, courtesy of Madalene P. and Jack Farris.)

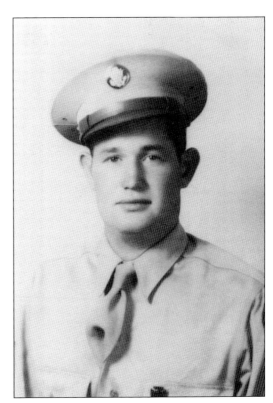

Earl's brother Jack (right) served in the Philippines, and brother Sam (below) served in the South Pacific. (Both, courtesy of Madalene P. and Jack Farris.)

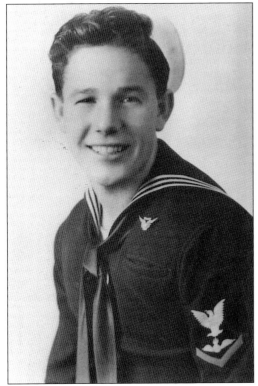

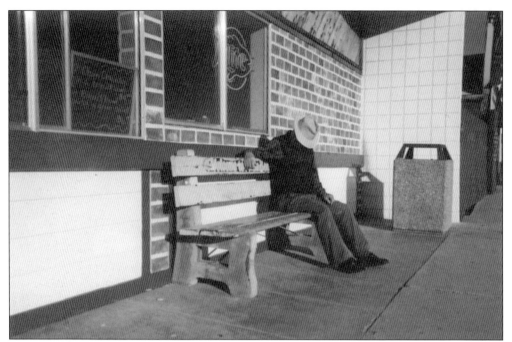

In retirement, as a Santa Maria Valley field supervisor, Earl B. Farris could be found on Front Street, having coffee at the Custom House (now a restaurant), riding around town on his moped, or taking a well-deserved snooze on the bench near the Avila Grocery. (Courtesy of Madalene P. and Jack Farris.)

Born in 1918 in San Luis Obispo, Gerard Parsons is a sailor, historian, and Port San Luis Harbor District founder and commissioner (1954–1976). His forward thinking helped obtain the tidelands and promoted policies to create and protect today's bay facilities. This image shows a 1960s pier, the yacht club, and Front Street businesses. (Courtesy of Jack A. and Cindy Farris.)

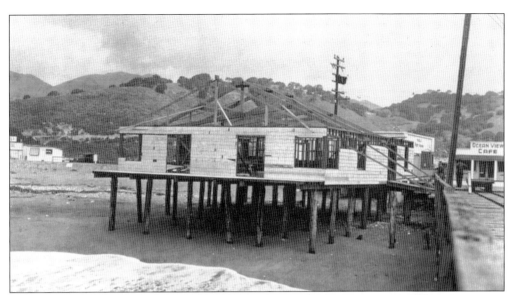

Gerard Parsons is a charter member of the San Luis Obispo Yacht Club and was instrumental in establishing the structure at the base of the Avila Pier today. This photograph shows the yacht club under construction in 1939. (Courtesy of the San Luis Yacht Club archives.)

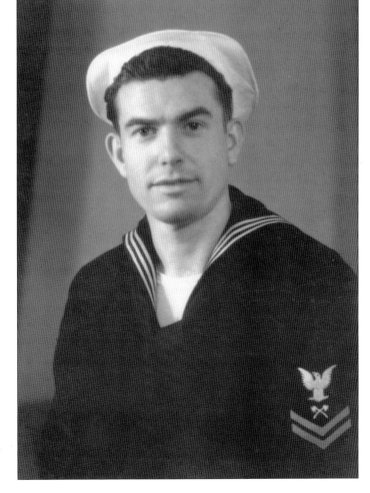

Parsons, shown here in his World War II Navy portrait, is a seventh-generation Californian. His mother, Ivy Brumley Parsons, taught at the one-room Port San Luis Schoolhouse around 1915. (Courtesy of the Gerard Parsons family.)

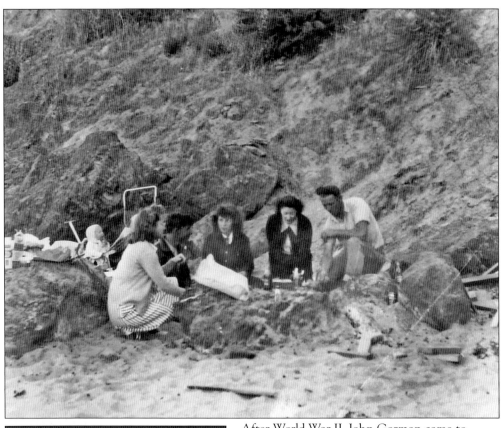

After World War II, John Gorman came to Avila Beach to work for Union Oil and found true love with local girl Marie Figueiredo. Here, they are enjoying a beach picnic with their new baby, Carol. From left to right are Carol, an unidentified friend, Sam Farris, Beverly McAnallen, and Marie and John Gorman. (Courtesy of the John and Marie Gorman family.)

John Gorman worked tirelessly for Avila Beach and Avila Valley, overseeing the town's septic services and moving them into the current wastewater treatment system. The John W. Gorman Wastewater Treatment Facility is named for him, one of Avila Beach's most influential public servants. (Courtesy of the John and Marie Gorman family.)

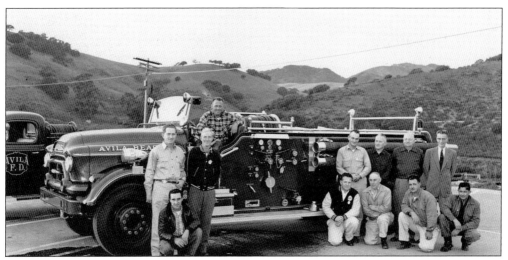

In the 1960s, Gorman (third from left) founded and was chief of the Avila Beach Fire Protection District. Here, he is encircled by firefighters, from left to right, Red Barker, Don Sylvester, Hayden Glenn, Eldon St. John, Perry Martin, Jim McMillan, Thomas Wickham, Harold Martin, Charles Caldwell, Joe Sylvester, and unidentified. (Courtesy of the John and Marie Gorman family.)

Gorman promoted the community as president of the Avila Beach Civic Association and mentored young people, purchasing fire manuals for budding firefighters. Stories of his acts of kindness and generosity abound. Avila Beach is a much better place because John Gorman lived here. (Courtesy of the John and Marie Gorman family.)

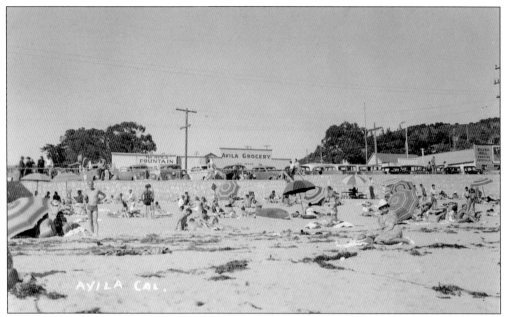

In this 1944 view of the Avila Fountain and Avila Grocery, the Silver Gull bar is further to the right, advertising "dancing and cocktails" to the soldiers during the war, the merchant marines from the oil tankers, and locals alike.

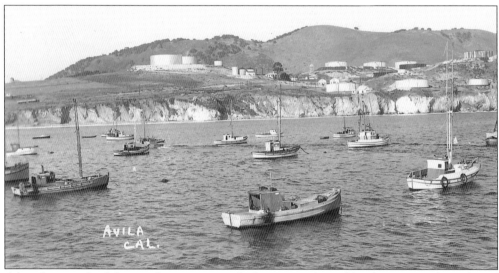

After the war, the fishing industry again picked up, as evidenced by the increased number of boats in the bay. (Courtesy of Beverly McAnallen Farris.)

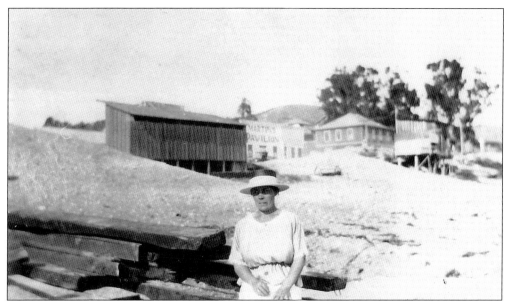

In 1901, Juan Avila gave permission for a school to be run in his Front Street two-story Bay Hotel (now the Inn at Avila Beach). Teacher Charles Ford started the school year with 36 students. Ollie Beck Jensen poses on the beach near the hotel. (Courtesy of Pat and Janet Farris.)

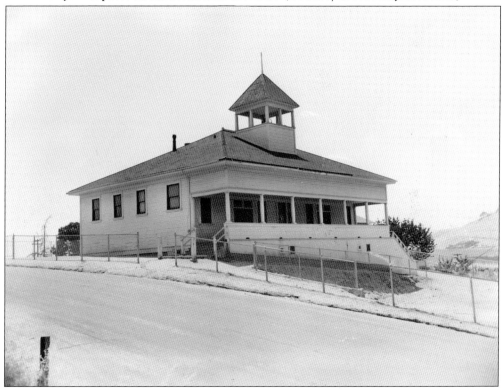

The first Avila Schoolhouse was built in 1903 and replaced in 1913 with this two-room building that still graces the hill on San Antonio and San Luis Streets. The original school featured a bell to call the children to school.

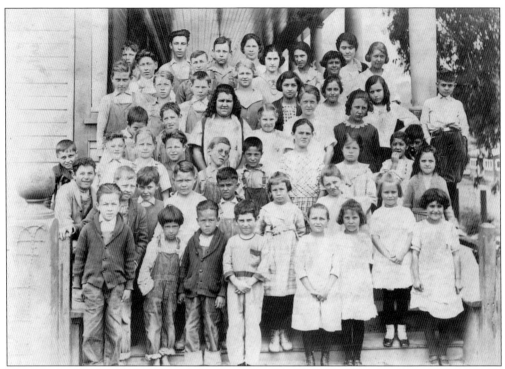

The larger school was needed for the influx of children whose parents were coming to Avila and Port Harford to work for Union Oil, Pacific Coast Railway, and the asphalt plant. This 1922 schoolhouse photograph reflects the large population of children in the community. (Courtesy of Pat and Janet Farris.)

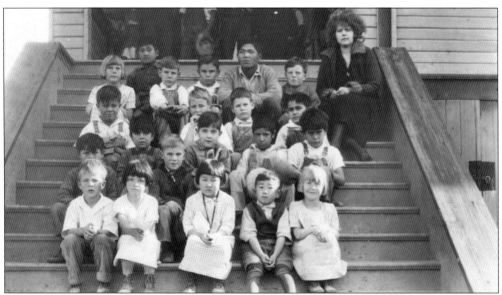

In the mid-1920s, Bernice Phoenix taught at the Avila School. This photograph from Marion Richard's daughter shows her mother in the front row on the right and her aunt Ruth on the top row at left. (Courtesy of Jane Fesler.)

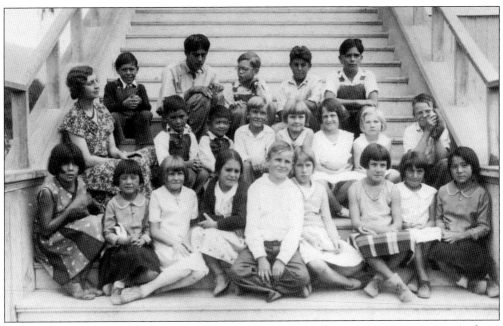

Union Oil paid the expenses and wages for a year for Maude Lawrence to come to Avila in 1927 to teach. This photograph shows her with her primary room students in front of the Avila Schoolhouse in the early 1930s. (Courtesy of Madalene P. and Jack Farris.)

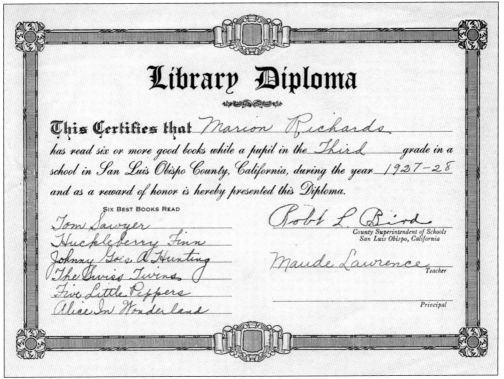

The 1927–1928 school year saw pupil Marion Richards receive a library diploma signed by Maude Lawrence for having read *Tom Sawyer* and *Alice in Wonderland*. (Courtesy of Jan Felser.)

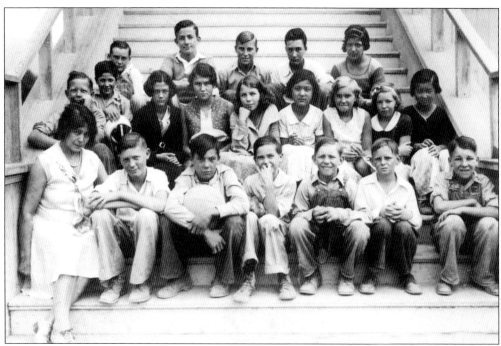

Laura Ruda, shown here, taught at the Avila School for over two decades. A memorable teacher, she made the students clean their spitballs from the ceiling with their bamboo fishing poles. (Courtesy of Madalene P. and Jack Farris.)

Maude Lawrence gathers schoolchildren for a 1940s class portrait. Pictured from left to right are James McMillan, unidentified, Ella Chase, Robert Martin, Jewel Farris, unidentified, Emily Figueiredo, Peter Chase, and George Martines. (Courtesy of Madalene P. and Jack Farris)

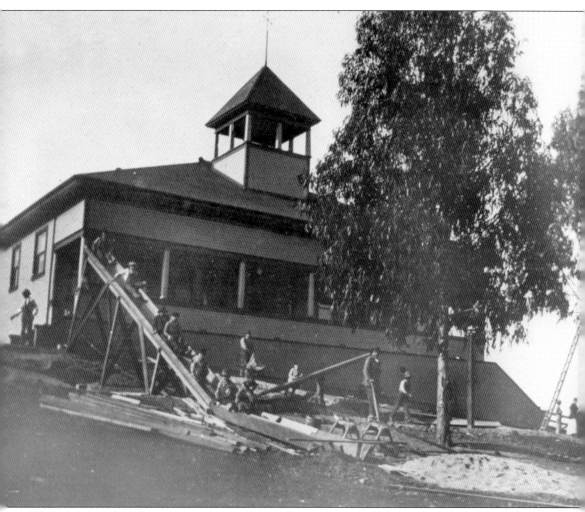

The school's bell and tower were removed for safety reasons, and it closed in 1966. Currently, the building is fragile, and concerned citizens are working to preserve its historic integrity. The property was given to the San Luis Coastal Unified School District. The district has since leased it and the surrounding property to developers, who have plans to build condominiums around the schoolhouse.

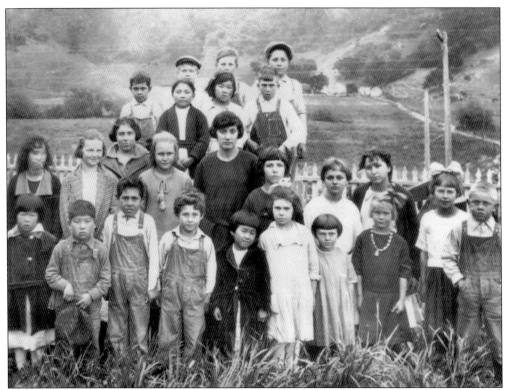
The Santa Fe Schoolhouse was built in 1907 for the children of Cave Landing and Miles Station. Children from local families such as the Villas, Koyanagis, and Dutras attended the school. Today, the carefully restored structure is the Salisbury Winery. (Courtesy of Madalene P. and Jack Farris.)

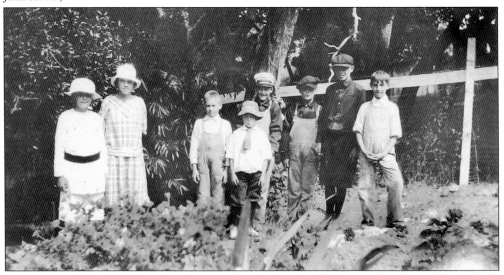
This c. 1916 photograph of Harold McAnallen (second from right) and fellow scholars of the Port San Luis Schoolhouse was taken during a break from class. Sadly no longer standing, the schoolhouse was located about a mile from the mouth of Diablo Canyon. (Courtesy of Beverly McAnallen Farris.)

Eight
OUR HERITAGE

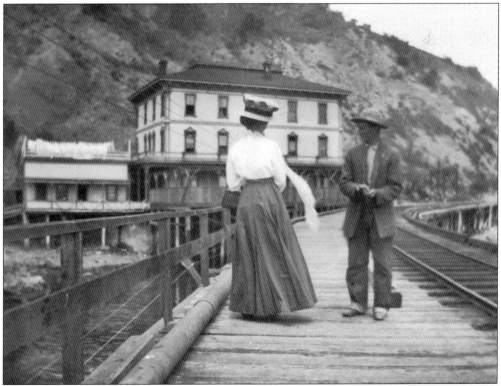

Folks in early 1900s walk on the pier in front of the Ocean Hotel, later renamed the Marre Hotel. The large oil pipe near the railing runs the length of the pier. Note the laundry hanging to dry in the ocean breeze on top of the washhouse.

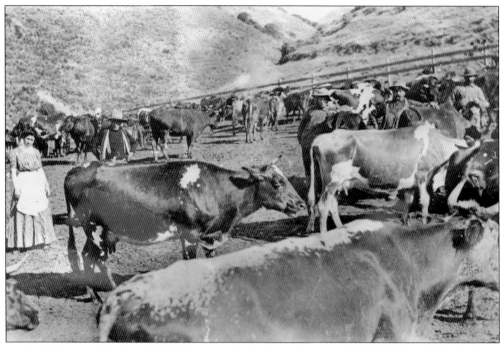

In 1910, the Vierra brothers (from the Azores) were running Luigi Marre's dairy, located between the lighthouse and Canyon Ignatius (near Diablo Canyon). From left to right are Mary Lucas Vierra, her husband John, and his brothers Antone, Joaquin, and Joe. (Courtesy of Jan and Louie Mello.)

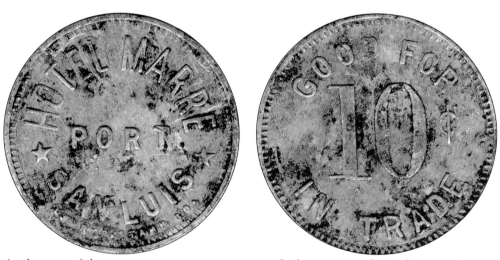

At the turn of the century, it was not uncommon for businesses to have their own form of currency. This is the front and back of a 10¢ tin token from the Marre Hotel. This souvenir coin could be used to purchase a beer or a ride on the Pacific Coast Railway. (Courtesy of Terry J. San Filippo.)

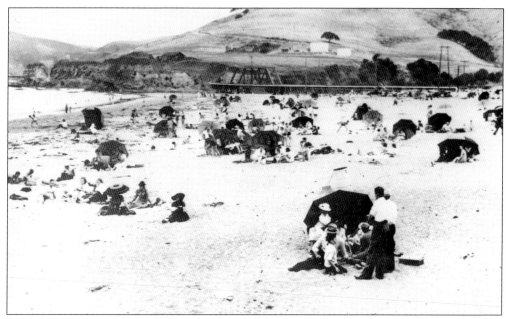

Swimming suits may not have been widely acceptable as appropriate attire in the early 1900s, but that never stopped Avila from being a popular beach. (Courtesy of Beverley McAnallan Farris.)

The Beck girls, from left to right, Birdie, Maudie, Ida, Ollie, and Irene, take a moment to pose for a picture in 1907. (Courtesy of Pat and Janet Farris.)

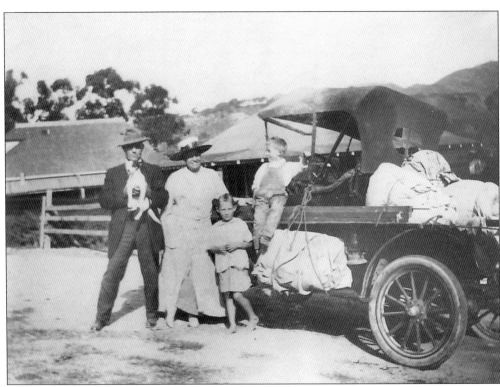

The Nels Jensen family lived on San Luis Street, formerly Avila Road. Nels holds the pup, and Ollie sits with daughter Vivian and son Raymond on the wagon. (Courtesy of Pat and Janet Farris.)

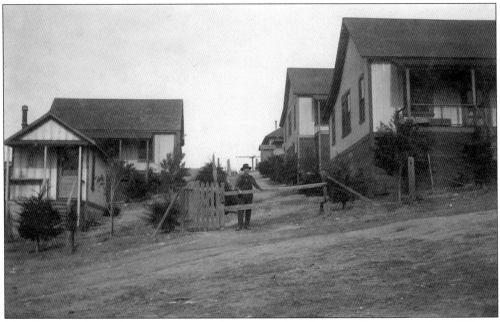

More homes make up the skyline on First Street today, but these wooden cottages from 1910 can also still be seen. (Courtesy of Beverly McAnallen Farris.)

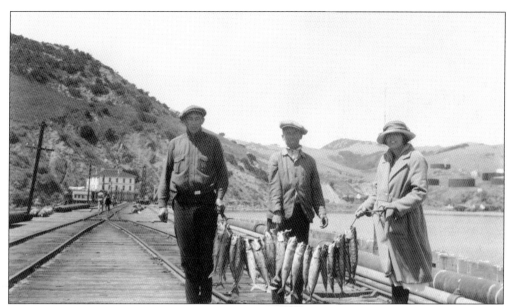

Will Richards (left) and Mr. and Mrs. Andrews show off their catch on the Port Harford Wharf in this c. 1915 photograph. Hotel Marre stands on the left side of the wharf, while the oil tanks dot the Port hillside. (Courtesy Jane Fesler.)

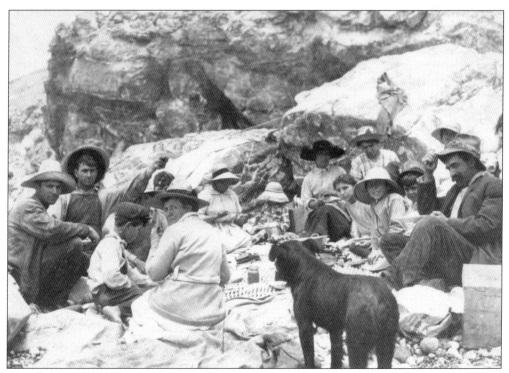

The Medeiros and Dutra families spend a sunny summer day picnicking at Cave Landing in 1917. (Courtesy of Madalene P. and Jack Farris.)

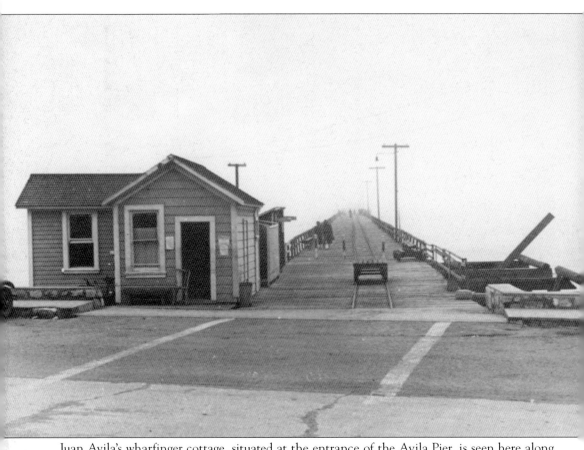

Juan Avila's wharfinger cottage, situated at the entrance of the Avila Pier, is seen here along with his pushcart, which he kept watchful eye over and would rent out for a quarter. Al Martin's stand is just beyond that, where local kids like Patrick and Cecil Brown worked, renting out fishing poles and selling 5¢ White Owl cigars, root beer, and candy. This photograph was taken on May 31, 1939.

This 1920s vista from Diablo Canyon shows cabins lining the canyon's mouth. Inhabitants were the Teeters, an old sailor named "Breakwater Slim," and Cabozone. On the left are terraces sans oil tanks, and in the bay, a tanker gets under way from the Union Oil Pier.

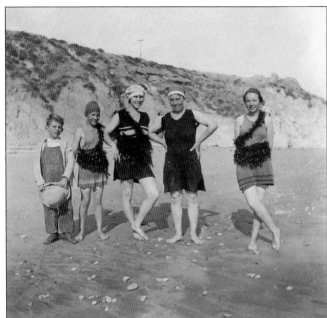

Festooned with seaweed, these 1920 Avila mermaids are, from left to right, Vivian Jensen; her aunt Irene Beck Delevee; Vivian's mother Ollie Beck Jensen; and an unidentified friend. Vivian's little brother Raymond is on the far left. (Courtesy of Pat and Janet Farris.)

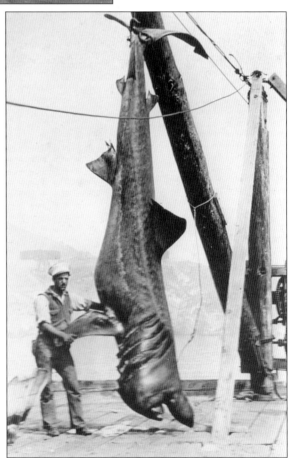

Mac Scuri poses with a basking shark catch. The shark had become tangled in the nets of his fishing vessel and died. (Courtesy of Madalene P. and Jack Farris.)

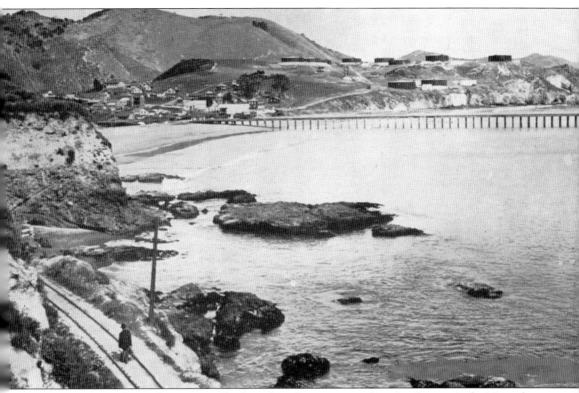

Manoel Silviera de Cunha Pintor walks the rail tracks connecting Port San Luis to Avila. Manoel, a Portuguese fisherman, built his Monterey-style fishing boat, the *San Antonio*, in the backyard of his home on San Luis Street.

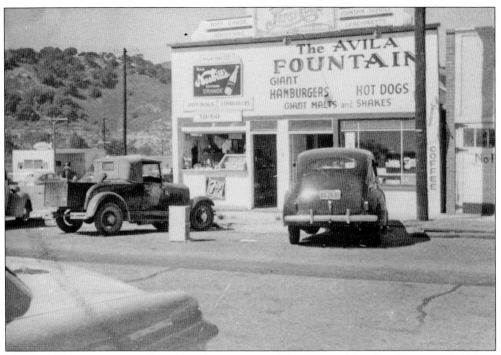

The Avila Fountain was a soda and hamburger joint on Front Street. Madalene Pintor worked there as a teenager, It was a hangout for the local kids and the merchant marines. Farris' Fish Market can be seen on the left of the photograph, with the cutout fish on the roof of the market.

Francisco and Maria Medeiros Dutra and family are at their dairy on Ontario Road In this c. 1930s photograph. From left to right next to their parents are Frank, Mary, Philomena, George, Anthony, and Alfred. Alfred served Grover Beach as a public servant for many decades, and the other sons became businessmen. (Courtesy of Madalene P. and Jack Farris.)

This postcard image dates to August 5, 1937, and depicts Al Martin's campground on the sand flats. Other families, such as the Houdeks and the Rudas, also had car campgrounds in and around Avila.

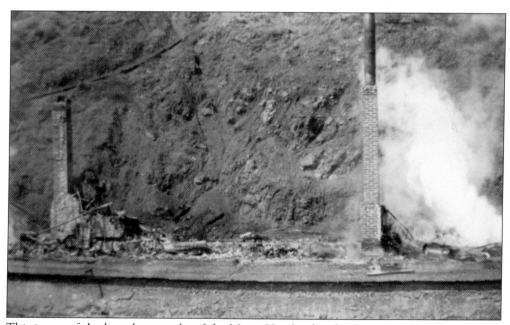

This is one of the last photographs of the Marre Hotel, taken by Constance Van Harreveld in 1934, a few days after the fire that demolished the once-historic hotel.

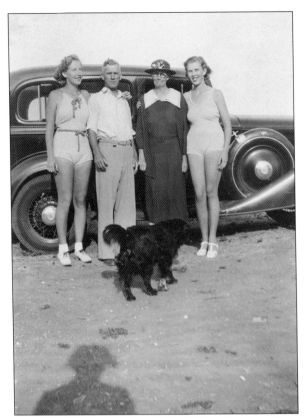

The late 1930s brought changes to Avila, including a more modern look in summer apparel. Sisters Ruth (left) and Marion Richards (right) take time for a family photograph with their parents, William and Minni, and their dog Lad. (Courtesy of Jane Fesler.)

These sand flats would later become home to hundreds of baseball games, the center point for local car clubs to meet, the future point of Al Martin's campground, the eventual destination of the Earl Farris parking lot, and the Avila Civic Center. For a large empty expanse in a small town, the area was extensively used. Note the school bell tower on the hill.

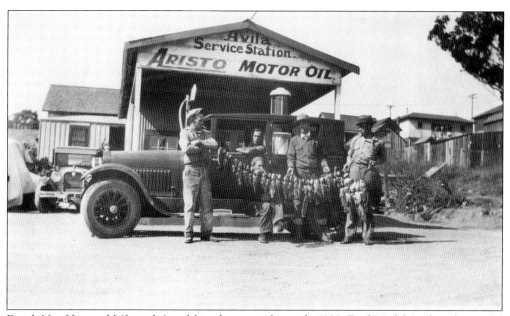

Dutch Van Harreveld (far right) and friends pose in front of a 1930s Ford Model A after a bountiful day of fishing. The Avila Service Station, the second fueling station in Avila, was located at the intersection of Front and San Luis Streets.

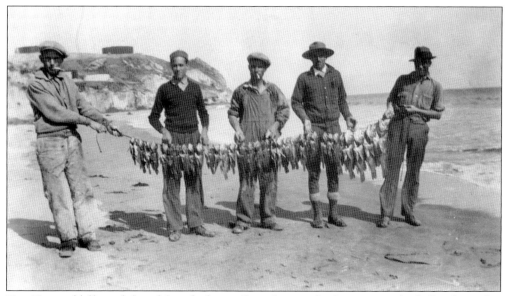

Van Harreveld (far right) and friends show off another catch, this time on Avila Beach, in this 1930s photograph. Fossil Point and oil tanks are visible behind the fishermen.

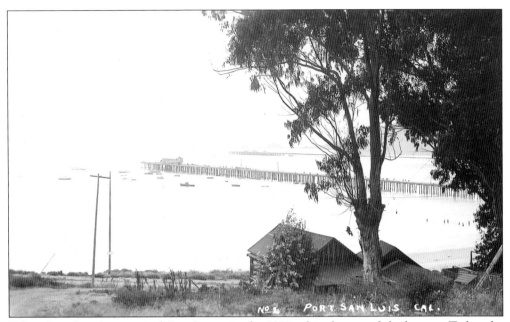

Taken from San Antonio and First Streets in the 1930s, this photograph looks west. Today, the eucalyptus trees are gone, the street is paved, and homes cover the hill. Pilings from the original People's Wharf can be seen on the right. (Courtesy of Beverly McAnallen Farris.)

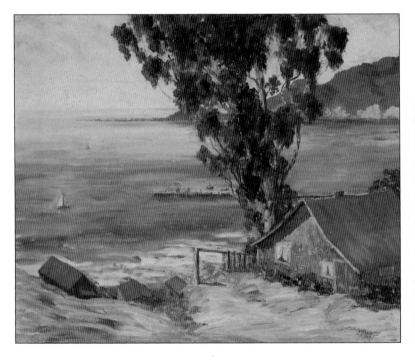

Ivy Brumley, a teacher from the Port San Luis one-room schoolhouse and Gerard Parsons's mother, produced this wonderful oil painting. The view is almost the same as in the photograph above. (Courtesy of the Parsons family and the San Luis Yacht Club archives.)

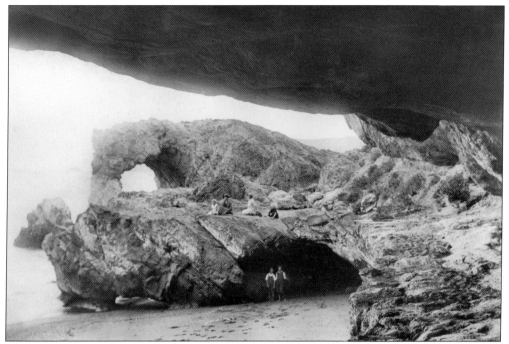
The William Richards family enjoys an outing at Cave Landing in late 1915. From the image, it is easy to understand why smugglers used the landing to store hooch. (Courtesy of Jane Fesler.)

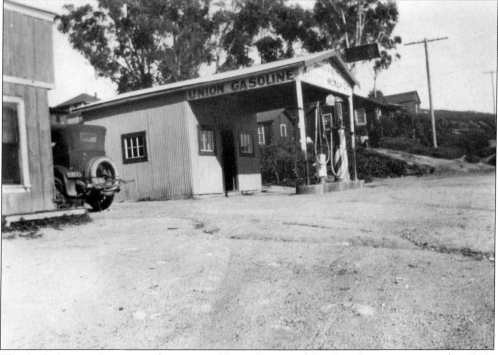
The Avila Service Station, at the corner of Front Street and San Luis Street, is seen in this 1930s photograph. It served the needs of automobile ownership during the 1920s and 1930s. Naturally, Union Oil gasoline was sold.

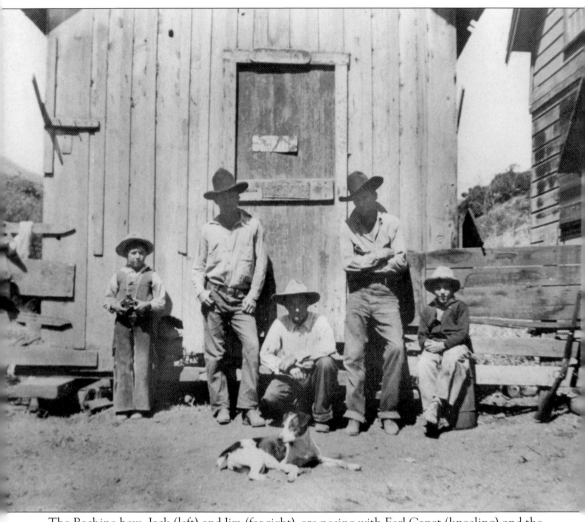

The Bachino boys, Jack (left) and Jim (far right), are posing with Earl Canet (kneeling) and the two Rodgers brothers in 1935. The dog's name is Spot. This photograph was taken in front of the Marres' saddle house, near what is the Avila Beach Golf Course today. (Courtesy of Mary and Jim Bachino.)

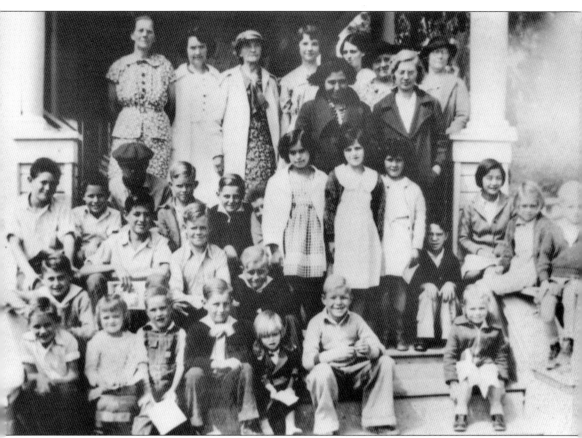

With the continued expansion of the Union Oil Company, the population of Avila had begun to grow relatively quick. This 1938 photograph of a Sunday school class was taken on the porch of the Avila Schoolhouse. The non-denominational Sunday school classes were held from the late 1920s until the mid-1960s, when they were moved to the newly constructed Avila Beach Civic Association building. (Courtesy of Madalene P. and Jack Farris.)

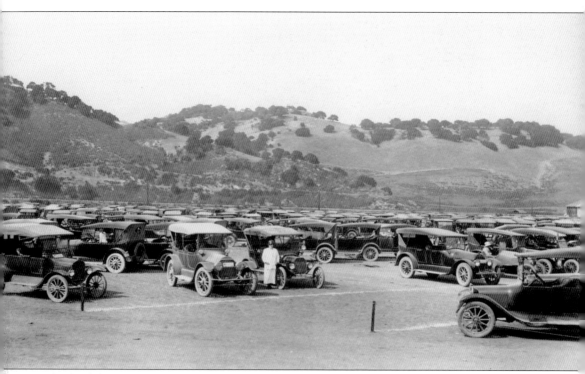

The sand flats at Avila provided the town with camping space during tourist season as well as a meeting ground for local car clubs, as pictured here in the 1930s. However, their favorite use for the local community was as a baseball field.

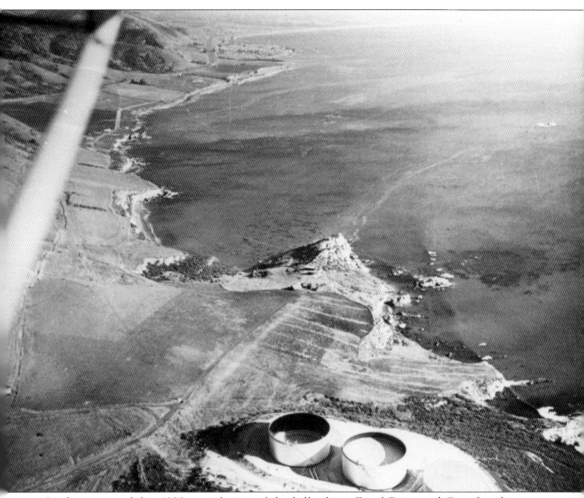
In the center of this 1930s aerial view of the hills above Fossil Point and Cave Landing are farmhouses whose inhabitants, such as young Frank Koyanagi and his parents, grew cantaloupes and peas. Note that the Union Oil tanks on the hills above Avila were not roofed, revealing the levels of oil within.

About two miles north of Avila lies See Canyon, named for early pioneer Rachel See. The canyon is known as a special microclimate for growing apples and, more currently, wine grapes. Evelyn Redstone (left) owned Daisy Dell fruit ranch, which has been a famous landmark in the canyon for decades because of its choice apples and cider.

The pioneers of the canyon have always had a connection with Avila. Chumash descendants the Sotos still have ties to the canyon, as do other early settlers of Portuguese and Irish descent. This 1900s photograph of ranchers and farmers near the Irish Hill Schoolhouse in See Canyon are, from left to right, R. Ruda, Charlie McIntre, and Francis McArdle.

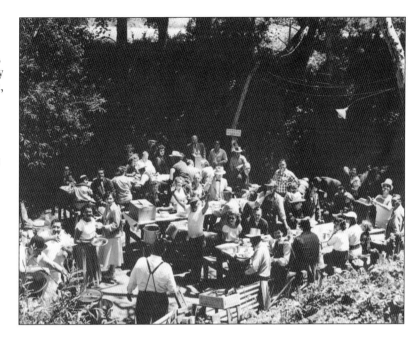

The See Canyon neighbors gather for a picnic, festa, or fiesta! Probably Chumash, Gaelic, Portuguese, Croat, and English were spoken. This image is from the 1930s. (Courtesy of Chris and Lori Benton.)

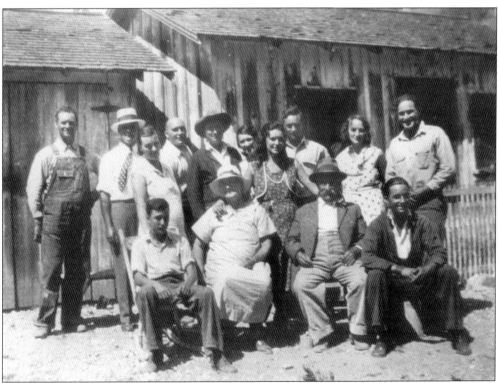

Antone and Georgia Ruda owned a See Canyon dairy ranch and orchards. From left to right are (sitting) Mitchell, mother Georgia Calloway Jones Ruda, father Antone Ruda Sr., and Joseph; (standing) Lewis Jones, Antone Jr., Mary, Ernest, John, Rose, Georgia, Frank, Mamie ?, and Manuel. (Courtesy of Nadine Lewis.)

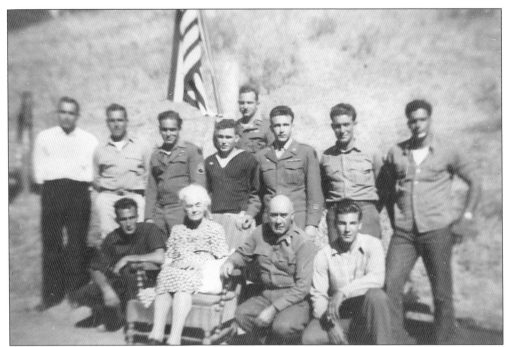

In the 1940s, the See Canyon Rudas celebrated the safe return of Georgia and Antone's sons and grandsons from military service on Father's Day. (Courtesy of Nadine Lewis.)

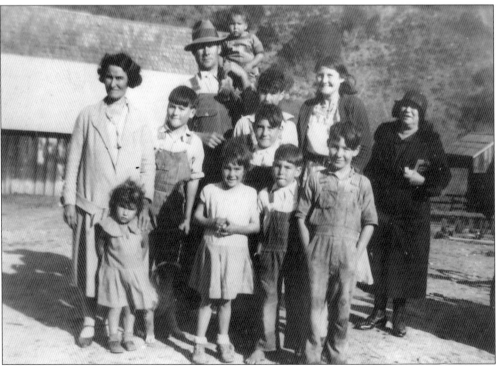

The Lewis and Mary Jones family from See Canyon pose with their children and their grandmother Silva. (Courtesy of Nadine Lewis.)

St. Peter's Chapel, built by Tony Dutra and Jack Farris on property owned by Pete Bachino at the top of San Luis Street, was dedicated in December 1953 by the Reverend Austin Matej of St. Paul's in Pismo Beach. Residents supported the effort through labor and the holding of fundraisers. The chapel was in use until the late 1960s. Prior to the construction of the chapel, mass in Avila had been held in an array of places, such as Union Oil's Scout Hall, Jack Farris's house, and Pete Bachino's garage. Little Anne Farris and her brother Jack can be seen in the family car. (Courtesy of Madalene P. and Jack Farris.)

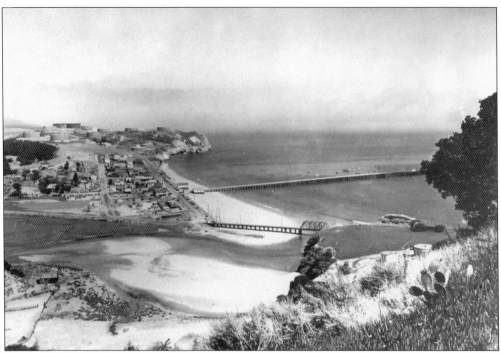

By 1955, with the economy on the mend, more and more tourists found their way to the quaint seaside community. Townspeople petitioned Vicente Canet, the postmaster, to work with the federal government to official change Avila to Avila Beach.

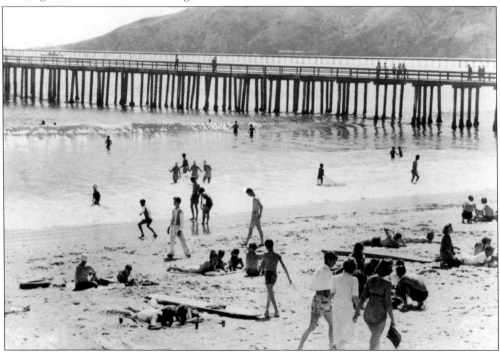

Cuesta College and California Polytechnic State University (Cal Poly, San Luis Obispo) students enjoy the beach scene in the 1960s. (Courtesy of Madalene P. and Jack Farris.)

The staff of the Olde Port Inn, located on the Port Pier (sometimes referred to as the Third Pier) poses on the back stairs in the summer of 1973. (Courtesy of Pete Kelley.)

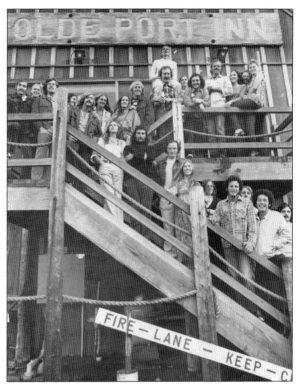

The Avila Beach Volunteer Fire Department in the 1970s included women and men with long beards and hair. (Courtesy of the John and Marie Gorman family.)

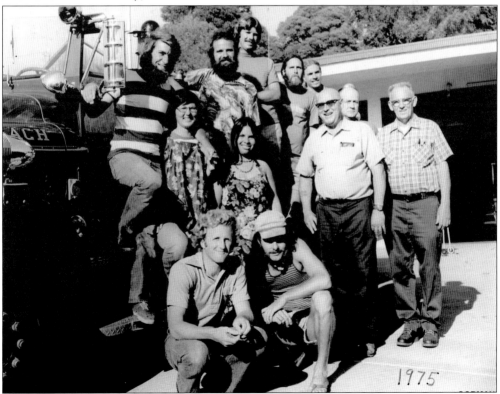

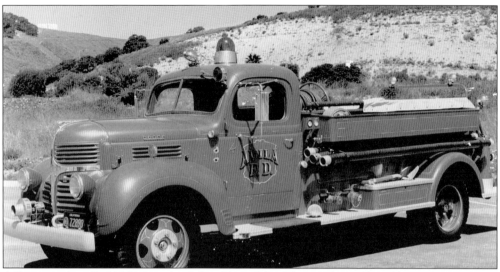

Affectionately called "Old Grandpa," the old-model red fire truck is still used by Avila Beach Cal Fire Station personnel. The truck makes appearances at special occasions, such as the Fourth of July pancake breakfast held annually at the local civic center. (Courtesy of the John and Marie Gorman family.)

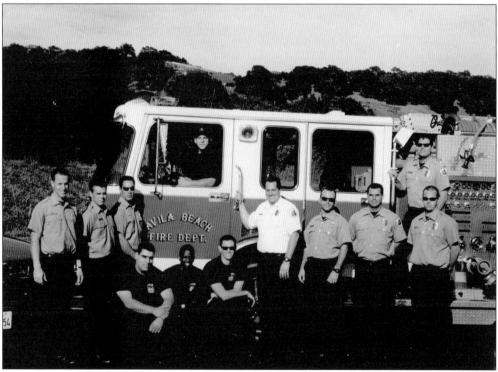

By the 1990s, the local volunteer firemen had adopted a more professional look. Recently, the volunteer district was taken over by Cal Fire protection. (Courtesy of the John and Marie Gorman family.)

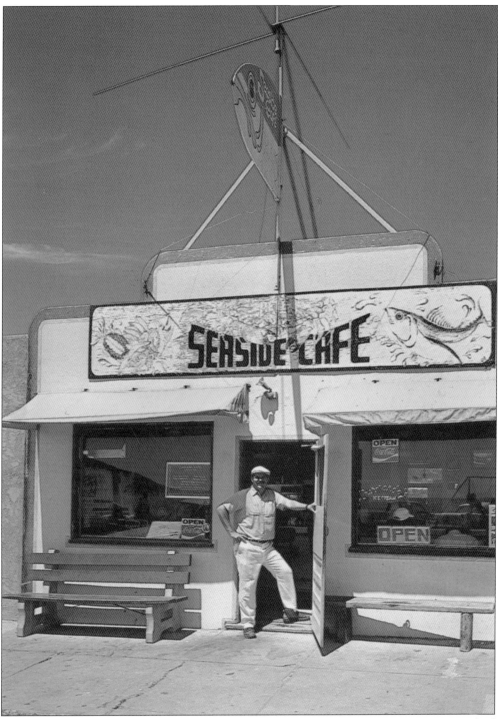

Pete Kelley, owner and chef of Pete's Seaside Café, long known for its savory Mexican seafood cuisine, poses outside his restaurant. This building was connected to the Barbara by the Sea bar. (Courtesy of Pete Kelley.)

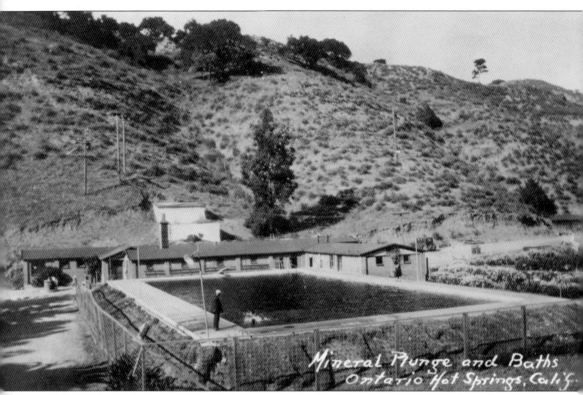

Herman Budan hit an underground artesian well of sulphur water when searching for oil near Ontario Road on the way to Avila. The prominent family consisted of Herman Budan; his wife, Hanna Christensen; and their six children. Although born in Germany in 1842, Budan made his way to the mining camps of the American West, where he worked alongside George Hearst in the districts of Utah and Nevada. He was instrumental in the discovery of the great Ontario Silver Mine in Utah. Later moving his family to California in order to pursue dairy farming, Budan purchased 200 acres near the entrance of what is now Avila Beach. A supporter of local politics and Republican in disposition, Budan was an important member of the county central committee, as well as an advocate for education and school improvement. In 1900, with the rising interest in oil along the Central Coast, Budan commissioned a man named Al Walker to supply the Budan place with an oil derrick, engine, and other drilling machinery. Budan died in December 1907.

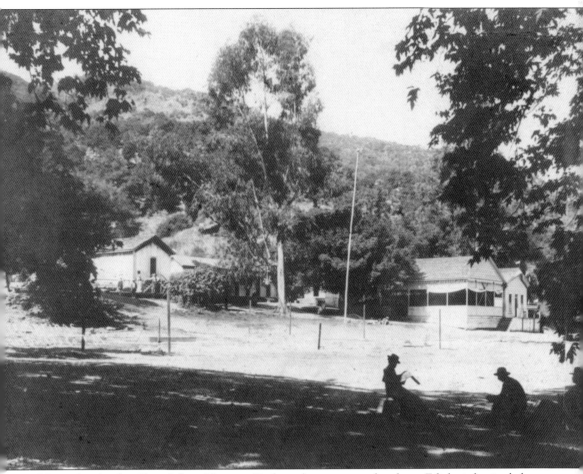

Upon the death of her father, Herman Budan, the youngest daughter, Edith, inherited the Ontario farm. She constructed a pool and bathhouse around the sulphur springs and renamed it the Ontario Hot Springs, opening the resort to travelers and locals alike. Promoting the healing properties of the 128-degree water, the Ontario Hot Springs became a renowned relaxation spot and was visited often by traveling film stars, including Charlie Chaplin. Edith was known for her incredible kindness and generosity, and she would supply local farms with free water long before plumbing came to the area. A natural entrepreneur, she later opened a restaurant and saloon on the property, and it was also rumored she would occasionally supply ladies of the night in the cabins behind the springs. Passing away in 1948, Edith donated the springs to charity. Since then, its ownership and its name have changed multiple times, and it is currently called the Avila Hot Springs.

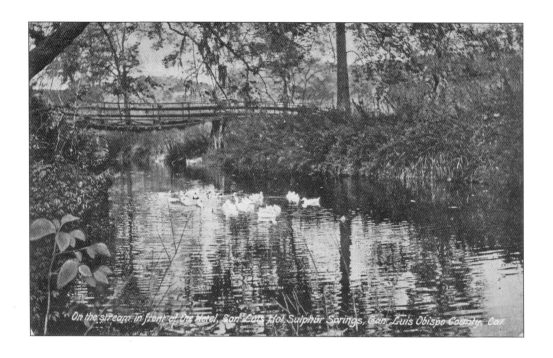

In the mid-1880s, hot sulphur water (instead of oil) was found near San Luis Creek between Ontario Road and Avila. Originally called San Luis Hot Sulphur Springs, the current resort, Sycamore Mineral Springs, features hot tubs and a restaurant.

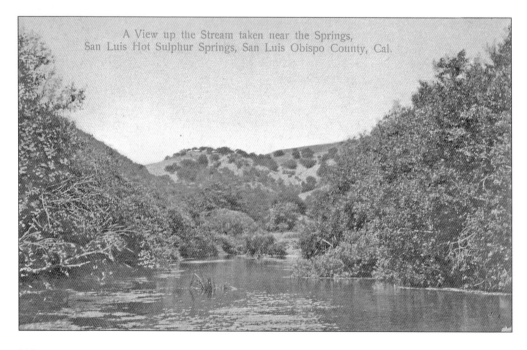

Barbara and Tom Dressio came to Avila as partners in an abalone business. Phasing out of that business, they then leased a café in Avila and called it Tommie's Place. In an earlier incarnation, it was called the Ocean View Café. This is the menu. (Courtesy of Pete Kelley.)

Ocean View Café
AVILA, CALIFORNIA

a-la-Carte

Fried Filet of Sole	1.25
Fried Shrimps	1.50
Fried Halibut	1.25
Fried Ling Cod	1.40
Abalone Steak	1.50

POTATOES, SALAD, BREAD & BUTTER SERVED WITH ABOVE ORDERS

Chicken Fried Steak	1.25
Baby Beef Liver, with onions	1.25
2 Fried Pork Chops	1.25
Lamb Chops	1.25
Hamburger Steak	1.00
Ham Steak	1.25
Tenderloin Steak	2.25
Baked Sugar Cured Ham	1.50
Fried Chicken	1.75
Shrimp Cocktail	.50
CHILI & BEANS	.50
CLAM CHOWDER	.50

The Dressios had purchased a building on Front Street from the Sylvester family. They opened a bar called Barbara by the Sea—according to some, the biggest and weirdest bar on the Central Coast. This photograph is of Barbara Dressio. (Courtesy of Finney Smith.)

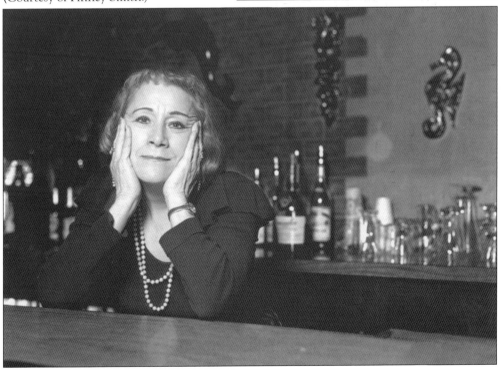

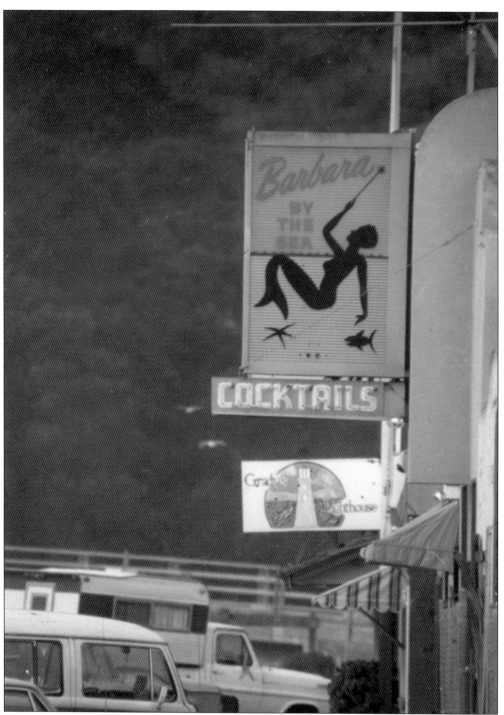
The mermaid logo on the Barbara by the Sea neon sign welcomed locals and visitors alike. The sign was a fixture in Avila for decades. (Courtesy of Mike Rudd.)

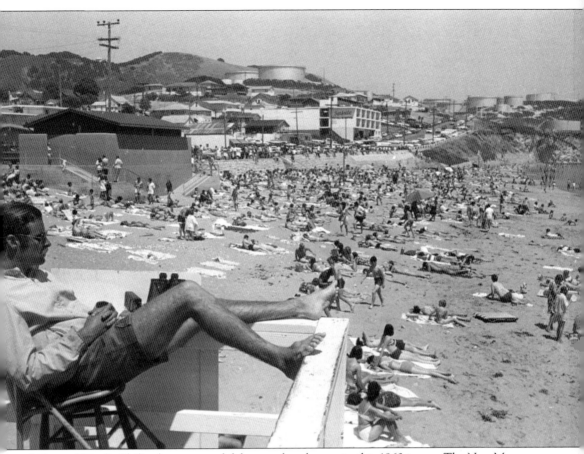

Lifeguard Hardie Philips keeps a watchful eye on beachgoers in this 1963 image. The New Moon Inn has long since been torn down. A public restroom and shower area can be seen in the left of the photograph. (Courtesy of the San Luis Obispo *Tribune*.)

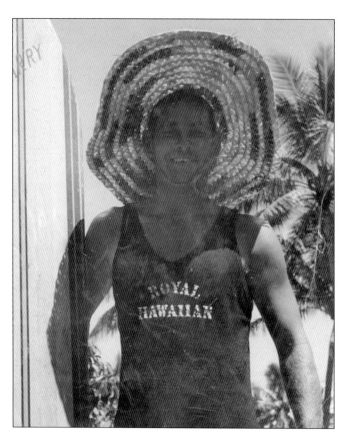

In the 1950s, Norman Coy Sr. moved to Avila, where he taught his children to surf. In the 1930s, he surfed and was a lifeguard at Waikiki. (Courtesy of Paula Coy.)

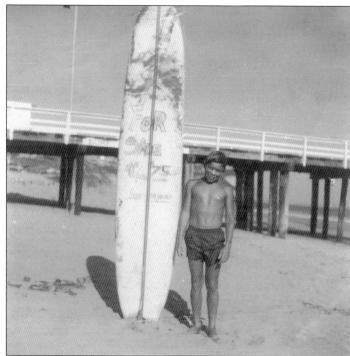

Elmer Coy, the top local surfer of his era, is pictured here on the west side of the Avila Pier. Every board Elmer rode was for sale. (Courtesy of Paula Coy.)

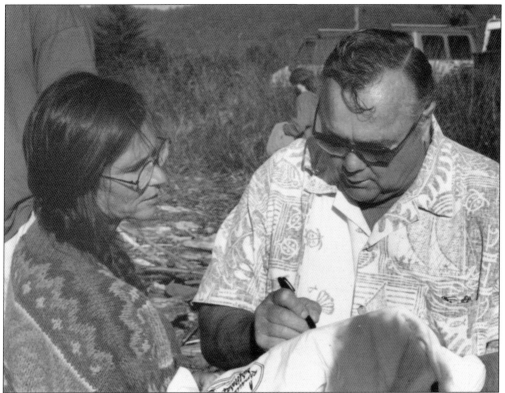

This photograph is of Avila local Paula Coy with world-renowned big-wave rider Greg Noll. Paula was (and perhaps still is) the best female surfer to come from the Central Coast. Noll, also known as the "Bull," fished out of Port San Luis in the mid-1980s. (Courtesy of Paula Coy.)

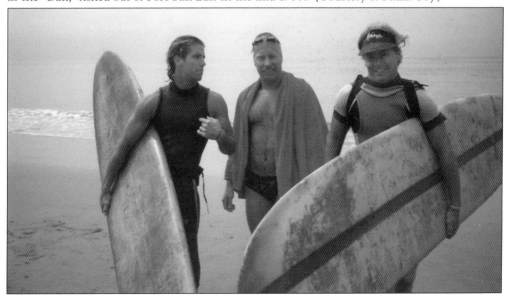

In the 1990s, Kevin Watkins, an Avila local, restarted the mile swim and run-swim-run. This event was halted when a shark killed an open-ocean swimmer five days before the 2003 event. From left to right are Chip Watkins, Kevin Watkins, and John Waterman. (Courtesy of Pete Kelley.)

The following 1980 photograph montage was created by Mike Monahan, seen here, a very creative artist who lived in the "barn" next to the Old Custom House Restaurant on the western corner of Front and San Luis Streets. He photographed all the area's curbs, sidewalks, and buildings. He then snapped shots of the people in front of their respective businesses or where they hung out. He pieced together over 1,000 images, making a three-dimensional piece enclosed in Plexiglas. This was, of course, before digital images and personal computers. Monahan wasn't aware of it at the time, but he created the last best image of the "Old Avila," the four blocks of downtown Front Street. No one in 1980 knew that downtown would be torn down, excavated, and rebuilt in what was referred to as the "Big Dig." An art professor at Chico State, Monahan took sabbaticals in Avila Beach until he retired. Known for his gregarious personality and creative mind, he was a colorful fixture in Avila Beach for many years. He now resides just south of Ensenada, Baja, Mexico. (Courtesy Mike Rudd.)

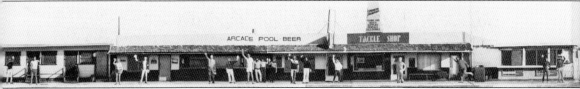

Frank's Long Dogs was on the corner (far right), a seasonal hot dog to-go joint. Next was French's Tackle Shop, run by John French Sr. His wife, Addie, was the Avila postmaster. Next to the French's was Grady's Lighthouse Bar, perhaps a biker bar. Grady was an ironworker, and he would cash his "brother" ironworkers' checks. Diablo Canyon Power Plant was being constructed then and was the largest job for ironworkers in the 11 western states. This is where they would relax after a long day with the "Devil" (as they called the power plant). Next to Grady's were three rustic studio apartments called "Grady's Condominiums." From the "condos" to San Juan Street was undeveloped property. This entire block is now the Lighthouse Suites Hotel. Perhaps they got their name from the original Lighthouse Bar? (Courtesy of Pete Kelley.)

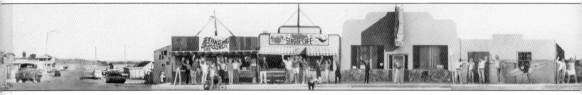

On the east corner of San Francisco Street, moving left to right was Stan's Schooner, Pete's Seaside Café, and Barbara's by the Sea. The Benjamin family, a great group of folks, ran Stan's. Earl Farris is in front on his motorbike. Pete's was connected on the inside to Barbara's. Pete's was the first café on the central coast to serve fish tacos, ceviche, fried plantains, and smoothies. The word "smoothies" had not been coined yet. Barbara's was mainly decorated with mermaid images from all over the world. One life-sized ceramic mermaid sat on the end of the bar. A sailor stole it, and the merchant marines put out a worldwide bulletin. It was returned within the year. At the end of the block, looking down San Francisco Street, one can see on the west the Avila Trailer Park and on the east fire chief Bret Percival's famous white cargo van. (Courtesy of Pete Kelley.)

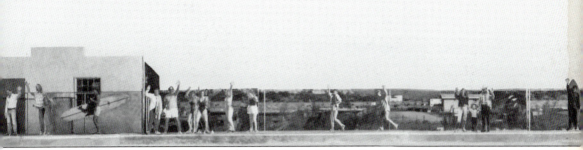

Mike put a lot of great people in this shot. With the long surfboard is Bret Percival, lifeguard and fire chief. The Jazzercise class that met at the yacht club is featured, as well as Paula Coy and Julie, her daughter. Roy Smith, the cement worker and union activist, is also here. (Courtesy of Pete Kelley.)

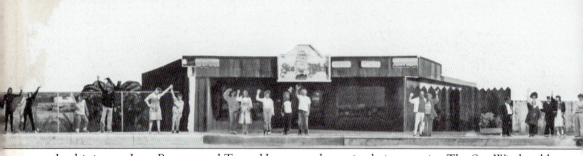

In this image, Jerry Burnett and Tanya Henry are shown in their wet suits. The Sea Witch sold beach sundries and had a small deli. It was also called "the Mayor's Place" after the owner's gregarious boyfriend. To the west, the large open space and fenced-off vacant lot was the site of Pete's Tackle Shop and the Fisherman's Inn, which was destroyed in a large fire in the early winter of 1978. The "New" Custom House and Mr. Rick's now occupy the west corner of San Miguel Street. (Courtesy of Pete Kelley.)

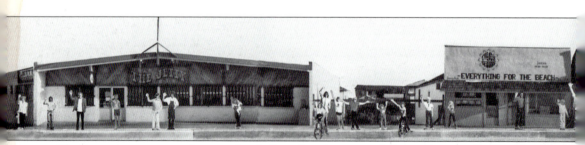

The Jetty restaurant, another popular Avila café and watering hole, was next to the Sun Shack. The "Shack" sold various and sundry beach supplies. The Jetty was a lunch and dinner spot, serving fish and chips, hamburgers, and such. Looking down San Miguel Street, one can see the Farrises' home, where Earl and his mom lived. Next door was Jake and Gladys Misakian's house and garage. Jake's was the last auto repair shop in Avila. Across the street was the Pizza Parlor and the laundry mat and, beyond, the Lo-tide motel. Andy's Munchies on the west corner of San Miguel was a fast food, soda, and shakes place. (Courtesy of Pete Kelley.)

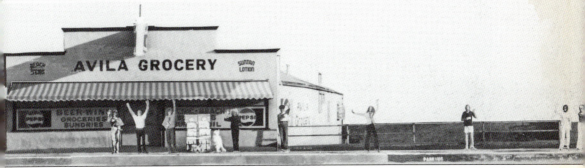

The Avila Grocery was next to the Old Custom House restaurant with Muzio's vacant lot in between. The grocery store and the yacht club were the only buildings removed for safekeeping and then restored to their original foundations once the "Big Dig" was completed. (Courtesy of Pete Kelley.)

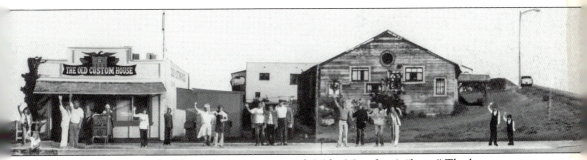

The east end is pictured of Front Street starting with Mike Monahan's "barn." The barn was an old structure that was remodeled and used for the movie *California Dreaming* in 1977. To the left is the Old Custom House, owned by Charlotte and Rick Wybell. The restaurant was the located in the original Avila Beach Custom House and was known for its large and tasty breakfasts. Up on San Miguel Street was the home of Florence and Perry Martin, known for their beautiful roses. (Courtesy of Pete Kelley.)

Discover Thousands of Local History Books Featuring Millions of Vintage Images

Arcadia Publishing, the leading local history publisher in the United States, is committed to making history accessible and meaningful through publishing books that celebrate and preserve the heritage of America's people and places.

Find more books like this at
www.arcadiapublishing.com

Search for your hometown history, your old stomping grounds, and even your favorite sports team.

Consistent with our mission to preserve history on a local level, this book was printed in South Carolina on American-made paper and manufactured entirely in the United States. Products carrying the accredited Forest Stewardship Council (FSC) label are printed on 100 percent FSC-certified paper.